BLACK AMERICA SERIES

AROUND
SURRY COUNTY

African American Communities: Surry Region

● Communities ○ Cities and Towns ＊ County Seats

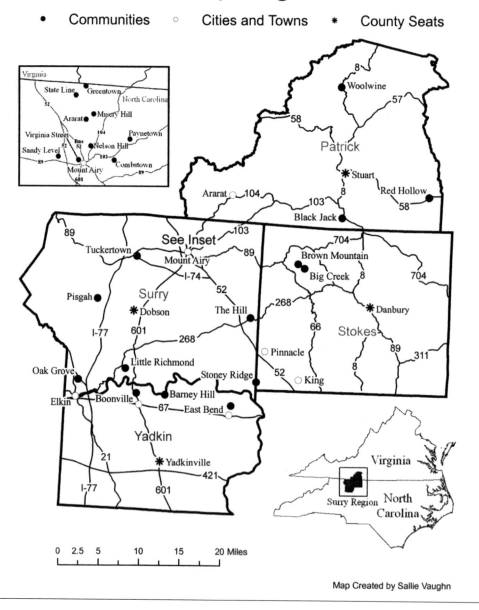

Inset:
Virginia
State Line Greentown
North Carolina
Ararat Misery Hill
Virginia Street 104 Paynetown
Sandy Level Bus 52 Nelson Hill
103
Mount Airy Combstown
89
601

Patrick:
8
Woolwine
57
58
Stuart
8
Red Hollow
58
Ararat ○ 104
103
Black Jack

Surry:
89
103
Tuckertown
See Inset
89
Mount Airy
I-74
52
Pisgah
Surry
I-77 601 Dobson
The Hill
268
Little Richmond
Oak Grove
Stoney Ridge
Elkin Boonville Barney Hill
67 East Bend

Stokes:
704
Brown Mountain
Big Creek 8 704
268 Danbury
66 Stokes
Pinnacle 89 311
52 8
King

Yadkin:
Yadkin
21 Yadkinville
421
I-77 601

Virginia
Surry Region North
Carolina

0 2.5 5 10 15 20 Miles

Map Created by Sallie Vaughn

BLACK AMERICA SERIES

AROUND
SURRY COUNTY

Evelyn Scales Thompson, Ph.D.

ARCADIA
PUBLISHING

Published by Arcadia Publishing
Charleston, South Carolina

Printed in the United States of America

Library of Congress Catalog Card Number: 2005924401

For all general information contact Arcadia Publishing at:
Telephone 843-853-2070
Fax 843-853-0044
E-mail sales@arcadiapublishing.com
For customer service and orders:
Toll-Free 1-888-313-2665

Visit us on the Internet at www.arcadiapublishing.com

This book is dedicated to those who honor the past to strengthen the future.

CONTENTS

ACKNOWLEDGMENTS

This book would not have been possible without the willingness of individuals to share precious family pictures and oral history. They come from four counties: Surry, Stokes, and Yadkin, all in North Carolina, and Patrick in Virginia. Many individuals from other states responded to the call for pictures. They are too numerous to name. We regret that space constraints prevented the use of all the pictures. Great appreciation is extended to Winnie Merritt, who encouraged the formation of the African American Historical and Genealogical Society of Surry County (AAHGS), the organization behind the book, and who, with Dr. Evelyn Thompson, gave impetus to the initial gathering of data. Each AAHGS board member set the full process in motion by knocking on doors to gather pictures and information. Many thanks go to Martha Vaughn for her publishing expertise; Sallie Vaughn for county maps preparation; James Penn, artist, and Ron Snow of Desk Top Solutions, who helped with images; and Buster Jones and Virginia Galloway, who helped with Needmore Street. Organizations that offered a helping hand by sharing pictures and/or information are the Surry County Historical Society; Mount Airy Museum of Regional History; the Genealogical Society of Surry County; Southern Historical Collection, Wilson Library University of North Carolina at Chapel Hill; the Patrick County Historical Museum; and the Mount Airy Housing Authority. Thanks to Adam Latham, at Arcadia, for words of encouragement that eased the mind and served to keep us moving forward. The support and understanding of family members are so much appreciated. It is hoped that this first book, about African Americans around Surry County, will promote greater understanding of and appreciation for the early life of people of color in the region and motivate others to write a piece of history.
 —The African American Historical and Genealogical Society of Surry County

INTRODUCTION

Most "others," that is, non-whites or non-northern Europeans, have been
simply invisible in the historical account.
—Carole E. Hill and Patricia D. Beaver, *Cultural Diversity in the United States South*

Alex Haley, with his book *Roots*, awakened Americans to an interest in genealogy. Since then, genealogists and historians have combed records for information about families. African Americans found few records to help them. As property, they had their names listed only occasionally; as free people, they rarely saw their accomplishments noted.

America was built on the backs of her workers—those unsung, ignored people who spent their lives contributing to society in quiet ways. People of color lived on the fringe of society, enduring racism and prejudice. Some made it to greatness, but most never captured the headlines of the local paper unless they stepped out of line. Despite their troubles, people of color persisted, reared families, and believed in America as the land of opportunity.

The African American Historical and Genealogical Society was formed to preserve the history and genealogy of people of color: African American and Native American. Black America Series: *Around Surry County* is a result of recent collections from people in the area. Many people came to Surry from Virginia and the surrounding counties in North Carolina; thus the name *Around Surry County*.

The goal of this book is to acquaint everyone with the history of a society that contributed to the growth of the region, to preserve that history, and to encourage others to embrace their own history and share it with future generations.

—Martha Rowe Vaughn

HISTORY

Rob a people of their sense of history and you take away hope.

—Wyatt T. Walker

The first inhabitants of the Surry region were Native Americans. African Americans became permanent residents in the 1580s when Sir Francis Drake arrived in Virginia with Negro slaves whom he set free. As the colonies grew and cash crops required larger portions of land, the need for labor increased, as did the threat of being enslaved. Many people of color fled to the mountains and foothills of Virginia and the Carolinas.

About 1747, Morgan Bryan, a Quaker, and his large family settled on both sides of the Yadkin River in Surry County. The land was rich with iron ore and had extensive hardwood forests to fuel the smelters for extracting iron. More settlers moved in, bringing slaves with them to work in the iron industry and farms.

According to the *North Carolina State Census of 1784–1787*, the total number of slaves living in the Surry region was over 1,000 persons. The *1860 Census, Surry County, North Carolina* reported about 1,200 slaves. The land was not suitable for large plantations, so the number of slaves in the Surry region never approached the numbers held by eastern plantation owners.

The Civil War changed the face of America forever. In 1863, Pres. Abraham Lincoln delivered the Emancipation Proclamation. Slaves fled the plantations during the chaos of war and joined the Union army. For the first time, African Americans in large numbers were a part of the United States military.

By the end of the war, slaves were freed but uneducated and unprepared for freedom. The Southern white population enacted the Black Codes in 1865, stripping Negroes of their new equality. Unable to vote, to travel freely, or to own land, Negroes were forced to take menial jobs The Black Codes were declared illegal and suspended in 1866, but the attitude of whites remained.

During the Reconstruction of the South, African Americans enjoyed a short period of freedom during which they held political offices, increased their education, and advanced their society. Soon they were targets of white supremacy violence ignored by officials.

The Jim Crow laws ushered in a different set of laws setting apart the races with its "separate but equal" declarations. Hard as the laws were on African Americans, the laws did allow a small step toward equality. African Americans set about forming their businesses, schools, churches, communities, and universities. They formed strong family, church, and community bonds.

The Civil Rights Act of 1964–1965 declared equality for all people regardless of race. However, the struggle for true equality for people of color continues today.

—Martha Rowe Vaughn

One

PLANTATIONS
A Life of Toil

God has not deserted us in our bondage.

—*Ezra 9:9*

The slave importation proposition of 1600, offered to the colonies in North Carolina, influenced the flow of slaves to the region. According to the proposition, settlers received 20 acres of land for each male and 10 acres for every female slave. However, slavery grew slowly in the Piedmont region. John Hope Franklin, the James B. Duke Professor Emeritus of History at Duke University, points out that one should not get the impression that whites generally enjoyed the fruits of slave labor in the 1860s since 80 percent of the Southern plantations had five or fewer slaves (from Slavery to Freedom: A History of Negro Americans, *4th ed.). The 1860 Surry County census lists plantations with the following approximate number of slaves:*

Plantations	Number of Slaves
63	1
113	2–10
19	11–20
11	21–46

Many owners worked with the slaves in the fields. By doing so, a more personal relationship of sorts was established. Greater understanding often led to trust and respect. However, family stories and history tell of cruelty, rape, separation of families, lack of food, and acts of degradation. The culture of the Africans was sacrificed in the process of building a nation.

Some masters gave the slaves land after the Emancipation Proclamation. One family tells how formerly enslaved family members remained in the area of the master's family and the two respected and supported each other.

Slavery produced a population of mixed-blood people. Children were born of African and European parents, African and Native American parents, European and Native American parents. Many attitudes that affect race relations today are influenced by previous black and white relations.

—*Evelyn Scales Thompson, Ph.D.*

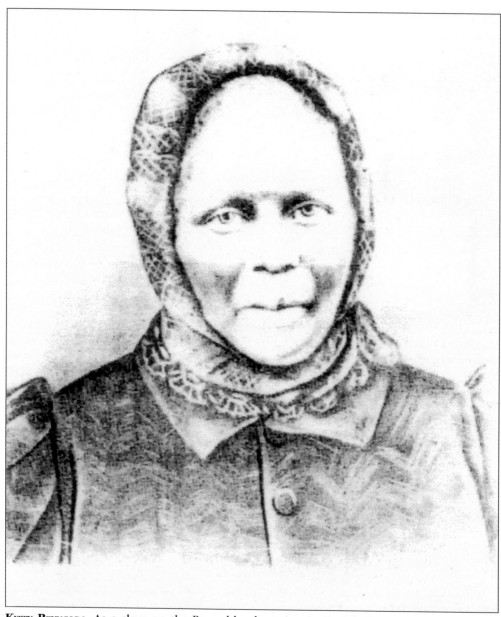

Kitty Reynolds. As a slave on the Reynolds plantation in Patrick County, Virginia, Kitty is remembered for her bravery. She once distracted a raging bull so that Hardin Reynolds could escape. In 1877, Kitty stood by her two sons being verbally harassed and attacked by two Shelton brothers, who were white. The altercation ended in the death of one white boy. The case went to the Supreme Court, and judges from several counties were indicted for excluding African Americans from juries, thus violating the Civil Rights Act of 1875 and the 14th Amendment to the U.S. Constitution. It became part of a group of cases known as "The Civil Rights Cases" for the protection of rights for former slaves. One son received a five-year sentence, and the other was acquitted. (Courtesy Kimble Reynolds and Thomas Perry.)

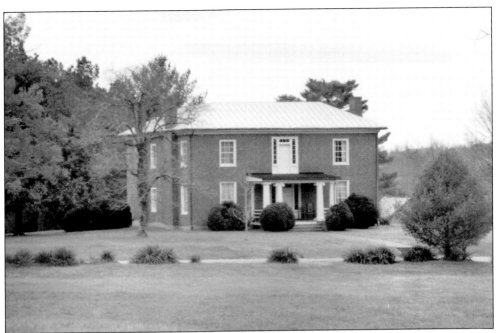

REYNOLDS'S PLANTATION. Built in the early 1840s by Hardin Reynolds, the house is one of the historic landmarks in Patrick County, Virginia. Hardin's father, Abram, purchased 50 acres of land in 1814 and settled in the area. In 1861, that county's slave population was about 2,000. (Courtesy Evelyn S. Thompson.)

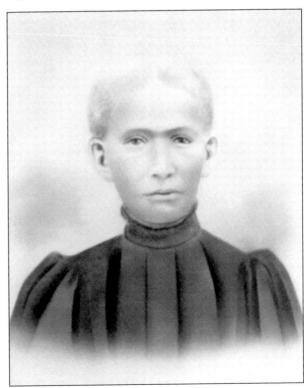

EVA JANE GILBERT PENN. Eva was born in Stokes County on a plantation in the mid-1800s. Her father was white, and her mother was black. Her granddaughter, Eva Bowman, said that her grandmother told her she was given special privileges on the plantation because of her light skin. She married Jerry Penn and reared eight children. (Courtesy Eva Penn Bowman.)

11

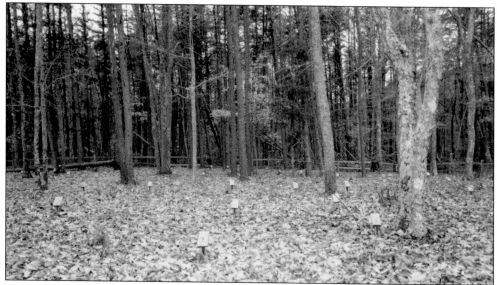

REYNOLDS'S PLANTATION CEMETERY. The gravesites of the slaves who died while serving at the plantation are located on the hillside near the house. Some of the stones that marked the graves have been replaced with markers. The site is fenced and preserved. (Courtesy Evelyn S. Thompson.)

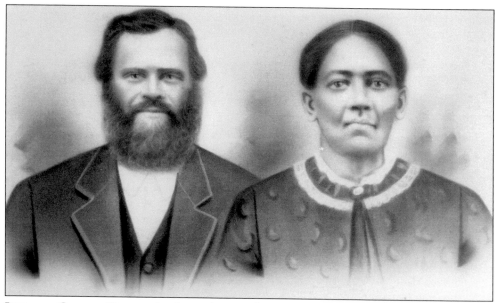

LEWIS AND CAROLINE DOBSON. Lewis was born to his master, William Polk Dobson, and a slave woman. Lewis hauled iron from the Dobson iron forge on the Fisher River to Raleigh for the construction of the capitol building fence. He helped to build the first courthouse in Rockford. Lewis traveled with William's son Joe Dobson, transporting food and supplies to Confederate soldiers in Richmond, Virginia. Caroline, of Cherokee descent, was bought from the Dunnagans. During their co-habitation on the plantation, they had eight children, and they had three more after they were freed. Lewis acquired 200 acres of land in Rockford. (Courtesy Evelyn S. Thompson.)

WILLIAM P. DOBSON PLANTATION.
William Polk Dobson settled on this plantation overlooking the Yadkin River *c.* 1802. Slaves supplied farm and iron forge labor. After William's death, his wife, Mary, maintained the plantation. The 1860 Surry County census lists her slave holdings as follows: nine blacks and five mulattos. The house has been renovated and is occupied today. (Courtesy Evelyn S. Thompson and James Penn.)

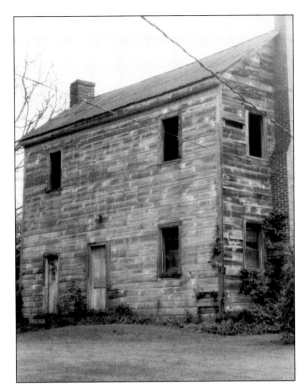

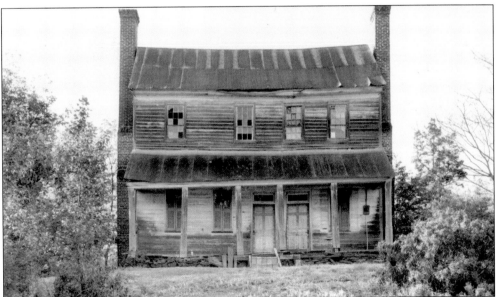

EDWARDS-FRANKLIN PLANTATION. Gideon Edwards moved to Surry County from Virginia in the late 1790s. He established a plantation of 2,330 acres along Fisher River. About 50 slaves did the work on his plantation. After her father's death in 1810, Mildred Edwards married Meshack Franklin and operated the plantation with about 60 slaves. The main crop was tobacco. A corn mill used until the 20th century stands on the property today. (Courtesy Surry County Historical Society.)

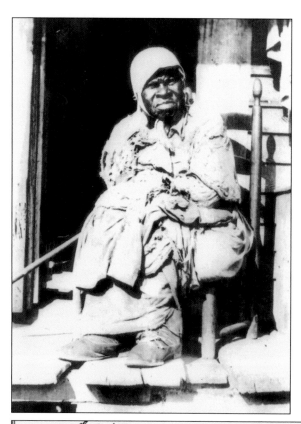

Grace Gates Smith (c. 1790–1915). Grace was born a slave in Alabama. In 1843, she became a wedding gift to Eng Bunker and his wife, Sallie, from the bride's father, David Yates. Eng and Chang Bunker were the Siamese twins who lived in Trap Hill, Wilkes County, and later moved to White Plains, Surry County. Grace was the nurse to their 22 children. She gave birth to nine children, three of whom survived: Jim, Jack, and possibly Jacob. (Courtesy Wilson Library of North Carolina at Chapel Hill and Brenda Etheridge.)

Death Certificate. Grace Smith, a slave on the Bunker plantation, died of "Rheumatism and old age" in 1915. It was estimated that she was 125 years old. A widow at her death, Grace was bought from a plantation in Alabama where she was born. (Courtesy Brenda Etheridge.)

Township _Mt airy_ CERTIFICATE OF DEATH
Town _White Plains_ Registration District No. _86-7063_ Certificate No. _87_
City............ (No. St.; Ward) [If death occurred in a hospital or institution give its NAME instead of street and number.]
FULL NAME _Grace Smith_

| PERSONAL AND STATISTICAL PARTICULARS | MEDICAL CERTIFICATE OF DEATH |

SEX _female_ COLOR OR RACE _Black_ SINGLE, MARRIED, WIDOWED, or DIVORCED (Write the word) _widowed_

DATE OF DEATH _Dec_ (Month) _14_ (Day) _1915_ (Year)

DATE OF BIRTH _not known_ (Month) (Day) (Year)

I HEREBY CERTIFY, That I attended deceased from19.... to19....
that I last saw h...... alive on19....

AGE _supposed about 125_ yrs....... mos....... ds....... If LESS than 1 day,.......hrs. or.......min.

and that death occurred on the date above stated, at _9 P_ .m.
The CAUSE OF DEATH* was as follows:
Hog no Doctor
Rheumatism and old
age. could remember the
Revolution war (Duration).......yrs.......mos.......ds.

OCCUPATION
(a) Trade, profession, or particular kind of work _At Home_
(b) General nature of industry, business, or establishment in which employed (or employer)

EDUCATIONAL ATTAINMENTS _none_

Contributory (Secondary)............
(Duration).......yrs.......mos.......ds.

BIRTHPLACE _Alabama_

(Signed) _S.E. Hannah Reg_
Dec 24 1915 (Address) _Mt Airy NC_

PARENTS
NAME OF FATHER _not known_
BIRTHPLACE OF FATHER (State or Country)
MAIDEN NAME OF MOTHER
BIRTHPLACE OF MOTHER (State or Country)

*State the Disease Causing Death, or, in deaths from Violent Causes, state (1) Means of Injury; and (2) whether Accidental, Suicidal, or Homicidal.
LENGTH OF RESIDENCE (For Hospitals, Institutions, Transients or Recent Residents)
At place of death.......yrs.......mos.......da. In the State.......yrs.......mos.......da.
Where was disease contracted, if not at place of death?

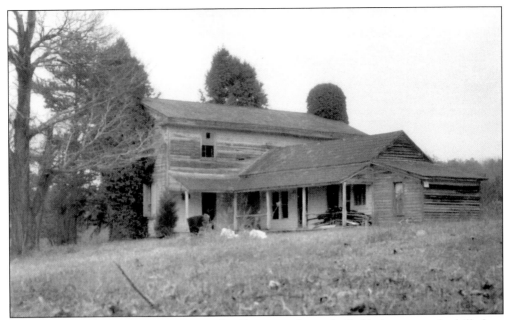

Joseph Dobson Plantation. John, son of William P. Dobson, built his house on the hill close to his father near Rockford. According to family oral history, the Dobson plantations shared the labor of the slaves. John's son Joseph inherited the plantation and in 1860 had 26 slaves. (Courtesy Evelyn S. Thompson.)

Slave Quarters. Plantations provided slave houses like this one on the Dobson Plantation in Yadkin County. They were placed to the rear of the master's house. One of several on a ridge under large shady trees, this house had one room with little or no furniture. The house was used mostly for sleeping or resting. (Courtesy Evelyn S. Thompson.)

ROCKFORD COURTHOUSE. The original courthouse was built with the help of the Dobson Plantation male slaves. They loaded and unloaded bricks carried by horse and wagon. Lewis Dobson, a slave, spoke of his work on the courthouse with his master. (Courtesy Evelyn S. Thompson.)

BILL SALES. Bill (1852–1956) was born into slavery, as were some of his children. He had three wives and three sets of children. Bill lived in Barney Hill, Yadkin County, with his third wife, Della Armstrong, where they were tobacco sharecroppers. He was honored as one of the oldest living citizens at the time this 1952 picture was taken. The celebration was held in the Barney Hill School. (Courtesy Deborah Sales Bowman.)

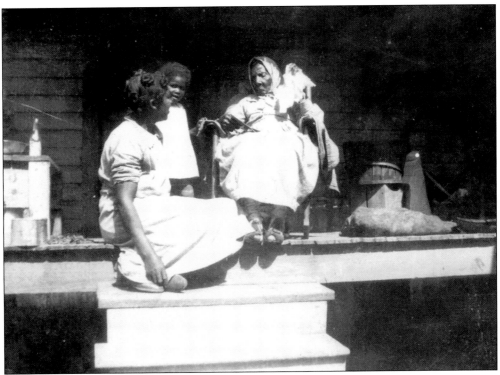

MARY WATKINS. Born a slave on the Pennel Plantation in Virginia, Mary was a gift to the Watkins Plantation. It was there that she wed Booker, who had lived on the Hughes Plantation before being sold to Master Watkins. A great-grandchild, Eunice, looks on as this picture was taken a few months prior to Mary's December 24, 1939, death, when Mary was in the care of her granddaughter, Nora Taylor. (Courtesy Lucy Nora Taylor.)

ROSE ELLA TRAVIS. Rose (1850–1928) was born in Patrick County, Virginia. The daughter of a Native American, she married William Nelson, Grant Qualls, and Walter Spencer. Rose and William lived in the Nelson Hill community, Surry County, named for William in 1880. Rose accumulated farmland, leased houses for $1 a week, and sold wood by the cord. She was also a midwife. Rose and Will gave land to build Shiloh Baptist Church. (Courtesy Charles Carter.)

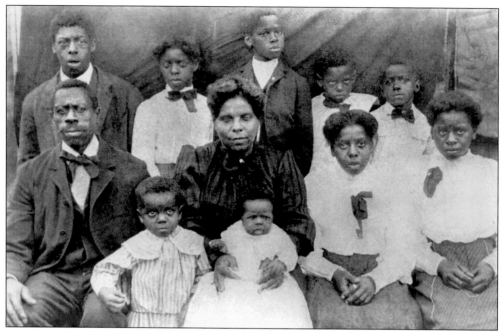

COCKERHAM FAMILY. William Woodson Cockerham (1858–1953) married Hulda (1872–1952). They had 15 children and were one of the original African American families of the Little Richmond area in Surry County. They were farmers. (Courtesy Brenda Etheridge.)

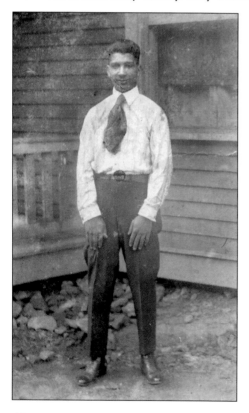

WILLIE HOOPER. Willie, the son of Lucy Harper, was born in Surry County in 1858. He worked as a farm laborer until he went to the coal mines of West Virginia in search of a better life. His siblings were Charlie, Martha, and Elizabeth. (Courtesy Emma Jean Tucker.)

Two

PEOPLE
Determined Roots

The night is beautiful, so the faces of my people . . .
Beautiful, also, are the souls of my people.

—Langston Hughes

The Emancipation Proclamation brought "freedom" to slaves but not the means to gain economic freedom. Some received a few acres of land, farmed, and hired out to work. Women earned money by washing and ironing for white neighbors. Some families placed their children in servitude in exchange for food.

Other freemen received no land and worked for former slave owners. As a tenant or sharecroppers, they divided their crops with the landowner. Getting ahead was difficult because of borrowing money against the crops.

During the Depression, black farmers suffered. Some sold their land and went elsewhere for work. Blacks who had a little money purchased land from departing neighbors. Land sold for 50¢ to $1 an acre.

Black people and hard times were well acquainted. In spite of discrimination, black parents wanted a better life for their children. They sent them to school and taught them to work hard and obey and honor their elders.

In spite of few economic opportunities, people believed working hard would bring a slice of the American dream. Blacks got a sliver. They were relegated to the lowest paying jobs and denied advancement.

Through it all, people of color remained determined, struggled not to be crushed emotionally, encouraged their children to learn, and continued to "ride hope" that one day they, too, would have opportunity.

—Emma Jean Tucker

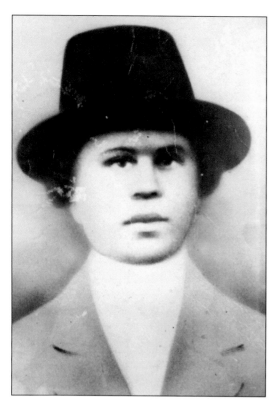

MELISSA WAUGH ALLEN. Shown in a 1934 picture, Melissa was the first wife of Ernest Allen. They lived in Dobson where she was a wash woman, cleaned houses, and cared for the children of white families. She had one daughter, Mary Bessie. (Courtesy Robena Jarvis.)

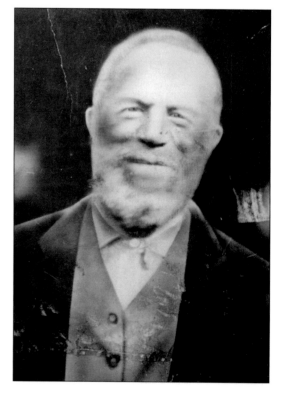

SAM SMITH. Sam married Mary Dison, who was born *c.* 1851 to John and Nancy Dison (Dyson), according to an application for money awarded to Eastern and Western Cherokee survivors and descendants of people alive during the 1835–1836 treaties. Sam and Nancy were living in Mount Airy in 1908 and had six children: Nat, Bud, Sarah, Rosa, Jennie, and Anna Mary. (Courtesy Francis Brim.)

Rash P. Clark. Rash (1858–1939) was born in Patrick County. He married Lue Helton in 1883 and moved to Stokes County in the Big Creek Westfield community. They purchased an 80-acre farm in 1893 for $13 an acre. The farm produced tobacco, corn, fruit trees, vegetables, apple cider, molasses, sauerkraut, milk, butter, and eggs. A spring served as a refrigerator. (Courtesy Levitha Mack.)

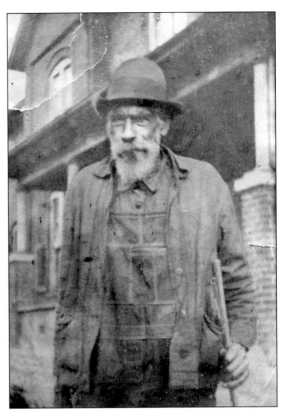

Milton and Harriet France. According to oral history given by Mary Ethel Moore, Milton's and Harriet's parents were slaves on the Eli Jessup Plantation in Stokes County and were later given land in Surry and Stokes Counties. Harriet Moore married Milton France, and they lived in a two-room log cabin with an attic and breezeway between the rooms. They reared five children. Milton never learned to read and write. (Courtesy Rev. Oliver Jessup and Mary Ethel Moore.)

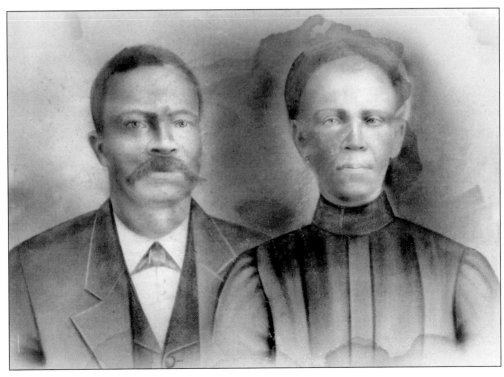

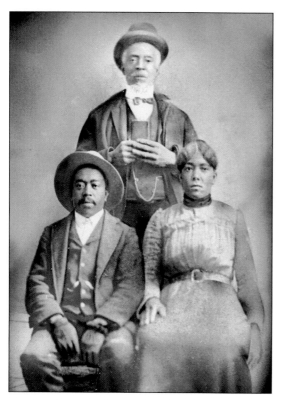

SMITH FAMILY. John and Mollie began their life together in a log house in Stokes County *c.* 1895. They owned a large tobacco farm on Tom's Creek in Stokes County and one at Chestnut Ridge, Surry County. Seven of their 11 children were born in the log house. They built a seven-room weatherboard house *c.* 1916, where they had three additional children. Pickney Smith (standing) is John's father. (Courtesy Edith Smith Jessup.)

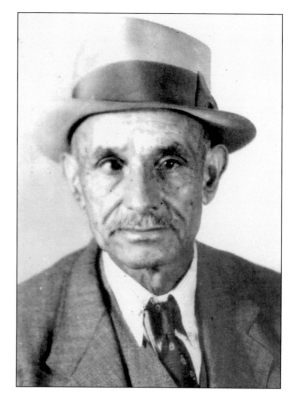

JAKE ARMSTRONG (1870–?). Jake bought 100 acres of land in the Barney Hill community, Yadkin County, after the Civil War. Family oral history says Jake was able to purchase land because he was thought to be white. His mother was Native American and European; his maternal grandmother was Cherokee. Jake donated land to build the one-room school and the church, while Mammie Carter, a neighbor, gave land for the cemetery. (Courtesy Deborah S. Bowman.)

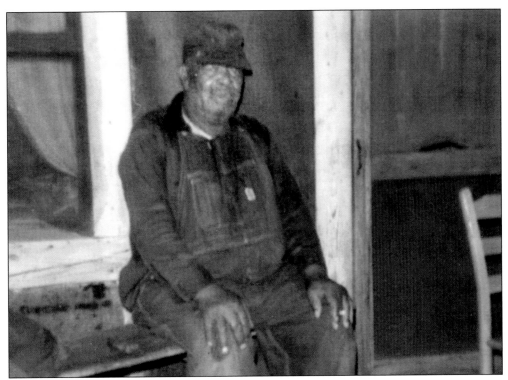

TOM SMITH. This sharecropper house was located on the farm of Roger Louis Nichols on Haystack Road in Surry County and was the last home of Tom and his wife, Grace. Tom was a sharecropper most of his life. He was the grandson of Grace Gates Smith, former slave of the Bunker twins. (Courtesy Brenda Etheridge.)

ARCH (1899–1954) AND LEE DOBSON (1895–?). This picture of these brothers was taken *c.* 1919 in Rockford, Surry County. They were sons of Lizzie and Peter Dobson. Arch married Mary Mathews in 1922 and worked as a farmer on the John Dobson farm in Rockford. Arch used his carpentry skills to build small buildings such as pig and chicken houses. (Courtesy Nora Dobson Penn.)

MOLLY GREEN AND JOE DOBSON. Molly (below) and Joe (left) were married in 1900 and lived in Rockford on a 40-acre farm. He acquired land from his dad, Peter, and the Dobson Plantation. Joe Dobson (*c.* 1878–1946) was the grandson of Lewis Dobson, a slave and the son of Peter and Jane Bowles. Molly and Joe's two-story house had two bedrooms upstairs, two bedrooms downstairs, a kitchen, and a sitting room. They reared seven children. (Courtesy Nora Dobson Penn.)

THOMAS AND LUTISHIE JOHNSON. Thomas Jeffery Johnson (1865–1933) and Lutishie Smith (1883–1951) came from Patrick County, Virginia. They lived in the Ararat community in Surry County and sharecropped on the J. D. Smith farm for 20 years. Lutishie was a housewife and cared for the seven children. Thomas owned his home and seven acres of land. (Courtesy Marie Johnson.)

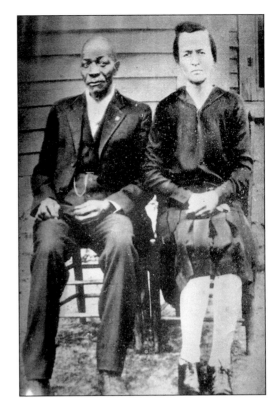

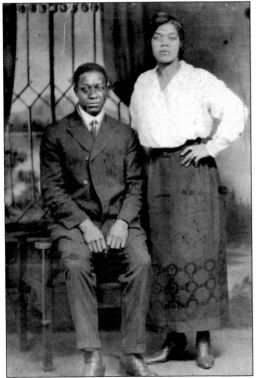

BOOKER AND MATTIE HAYNES. This brother and sister were from Devotion Mountain, Surry County. According to Melvin Morrison, the Thompson, Haynes, and Gadberry families received land grants to move into the area. They were farmers and sold their produce to neighbors. Booker worked for Dillard Reynolds Estate. Jennie, another sister, was a housekeeper for the Reynolds family. Jennie's husband, Reverend Bailey, was originally from Asheville and was the pastor of the New Homes Baptist Church in Devotion. (Courtesy Melvin Morrison.)

LUCY DOBSON. Lucy (1892–1982) was born to Jack and Mollie Dobson of Rockford and married Dillard Ceasar. They made their home in Surry County on Wards Gap Road and reared eight children: Viola, Alma, Helen, Stella, Dorothy, Billy, and Marion. Lucy worked as a domestic. Her daughter Helen was the first African American from Surry County to serve in the WAC. (Courtesy Calvin Ziglar.)

BARTLEY COX. Bartley and his wife, Minerva Jessup, whom he married in 1890, made their home on a farm in Stokes County. They had 15 children, 14 of whom grew to adulthood. After the 54.5-acre farm was swindled from the family, they relocated to a nearby 33.5-acre farm they owned. Bartley died in 1950. (Courtesy Bernice Cox Lowe.)

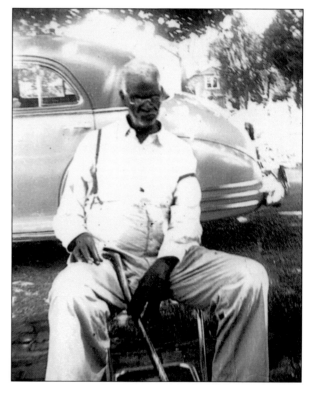

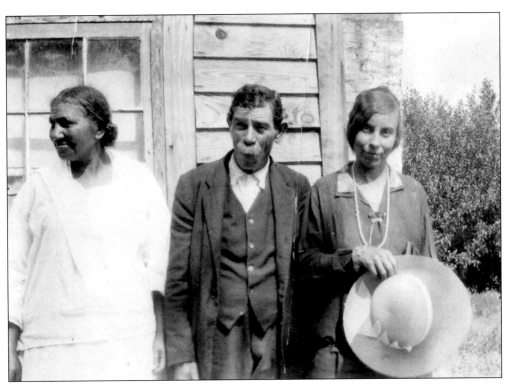

JAMES M. AND NANNIE JOYCE. James Joyce (1879–1940) and Nannie Walker (1876–1945) were married in 1893. Both were born in Patrick County, Virginia, and moved to Surry County, where they farmed. They could not read or write at the time. Their children are as follows: Annie, James Arthur, Alonzo, Earl, and Maggie. Pictured with them in this *c.* 1920 photograph is their oldest daughter, Annie (far right). (Courtesy Brenda Joyce Thompson.)

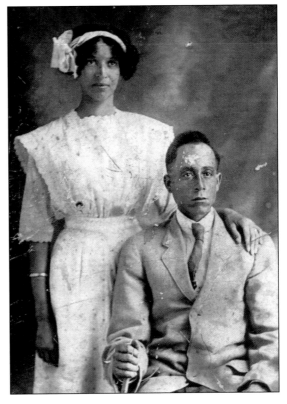

WALTER AND ETHEL BOWMAN. Walter Bowman (1883–?) was married to Ethel Dyson (1895–?).They lived on Wards Gap Road in Mount Airy. Walter served as deacon of his church and taught Sunday school for years. He was a chief stonecutter at the granite quarry. They had four sons: Claude, Walter Jr., Floyd, and Roy. (Courtesy Roy Bowman.)

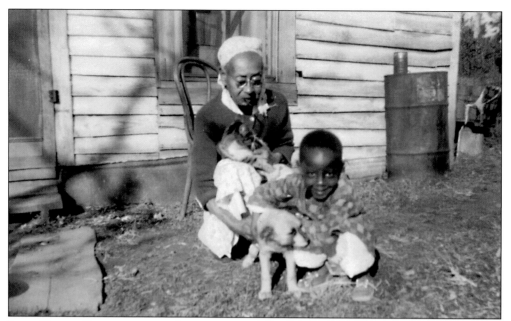

LIZZIE KELLAM. Lizzie was married to James Joyce, and they had 12 children. They lived in Pilot Mountain where they farmed. James was a former slave in Stokes County and was educated by his owner. He became a teacher in the community. In later years, Lizzie was a babysitter for neighborhood children, as shown in the photograph. (Courtesy Lydia Lovell.)

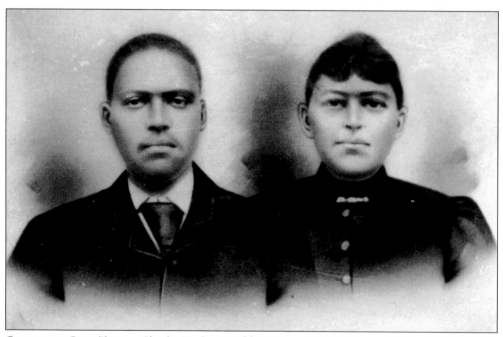

CHARLIE AND OLLIE TUCKER. Charlie Tucker (1866–1953) and Ollie Grogan Tucker (1875–1961) lived in the Pine Ridge community. Ollie was born in Freetown, near Dobson. Charlie and Ollie were married in 1894 and had 11 children. Charlie and Ollie are buried in the family cemetery. (Courtesy Emma Jean Tucker.)

LILLIE ALICE DOBSON GREEN SMITH (1899–1974). Lillie Alice was born in Rockford, Surry County, to Samuel and Liza Bowles Dobson. She married Walter Green (1880–1923). They lived on what is now Parker Road. Walter traveled to West Virginia to work in a coal mine. Lillie Alice remained in Mount Airy with their small children. Walter was killed in an accident inside the mine. Many years later, Lillie Alice married Reid Smith. (Courtesy Rosa Tucker Opoulos.)

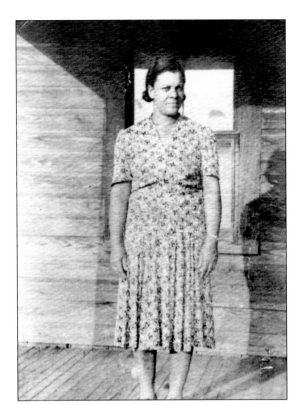

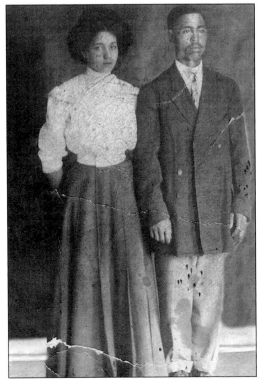

JOHN AND MARY HELTON. This picture was taken on the wedding day of John Wesley Helton and Mary Elizabeth Dyson in 1912. They made their home north of Mount Airy in the Ararat community. They had eight children. Wesley worked for a monument company and Hannah Funeral Home; he died in 1951. Mary died in 1955. (Courtesy Jettie Forrest Helton.)

29

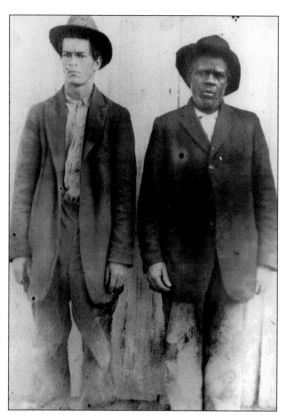

GEORGE GREEN AND LEE TILLEY. George (left) was Lee's stepson. They were farmers in Surry County and Ararat, Virginia, respectively. George married Hattie McCarther and had 12 children. George's parents, Mandy Dyson and John Green, divorced after having three children. Lee and Mandy Dyson had one daughter. (Courtesy Claude Smith and Frances Green Sales.)

ROBERT AND JOSEPHINE TILLEY DISON. The Dison family has been traced to Caswell County, Virginia. Robert ("Bob") and several of his siblings applied for Cherokee treaty funds, claiming descent through grandparents Frederick and Nancy. Bob (1842–1944) married Josephine Tilley (1849–1929). They were farmers in Surry County and had large land holdings. Bob sold land to the board of education in 1907 and gave land to build State Line Primitive Baptist Church. They had six children and lived in the Ararat community. (Courtesy Ronald Scales.)

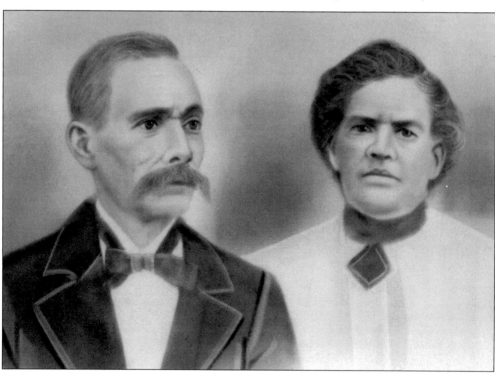

ADA STEWART. Shown in this *c.* 1888 photograph, Ada was born in 1868 and married Calvin Tucker in 1883. They had four children, Annie Coyal, Olivia, Willie Thaxton, and Bernard Hatteras "Coot." They lived on Needmore Street (Virginia Street) in Mount Airy. Calvin had horses and wagons and hauled iron and logs. (Courtesy Thaxton Tucker.)

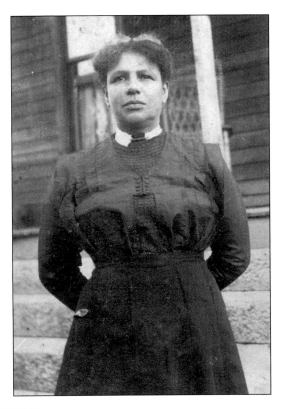

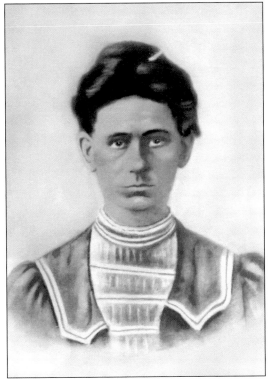

MARY HILL SCALES. Mary (1865–1912) married James M. Scales. In 1907, Mary applied for funds allocated to Cherokees under the treaties of 1835–1836 and 1845 between the Cherokee Nation and the United States. She wrote, "The Fulkerson's took my great-great-grandmother from the Indians and gave her their name." The government rejected her application stating, "The ancestor through whom Cherokee descent is claimed was a slave." She lost her Native American name and tribe. (Courtesy Evelyn S. Thompson and Lydia Bennett.)

31

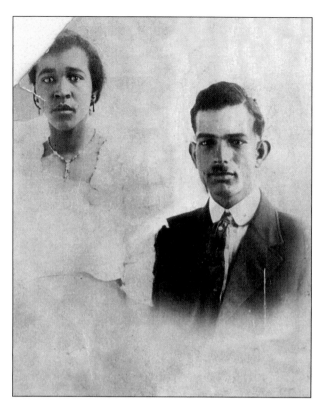

RICHARD AND NETTIE DOBSON. Richard (1897–1967) and Nettie Helton Dobson (1900–1939) lived in the Ararat community of Surry County and had six children. Richard worked at the granite quarry until retirement. He helped to move granite to Akron, Ohio, for the construction of the Firestone Monument. Nettie worked as a domestic. After Nettie's early death, Richard married Mary Nelson. (Courtesy Barbara Tucker Claytor.)

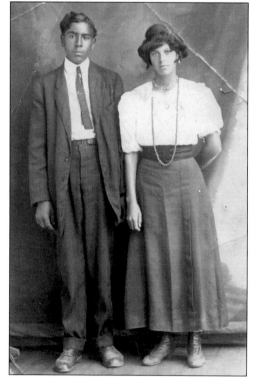

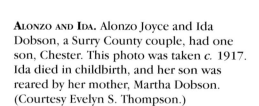

ALONZO AND IDA. Alonzo Joyce and Ida Dobson, a Surry County couple, had one son, Chester. This photo was taken c. 1917. Ida died in childbirth, and her son was reared by her mother, Martha Dobson. (Courtesy Evelyn S. Thompson.)

NELLIE FULTON. Nellie (1892–1976) was the second daughter of John and Fannie Dyson. She married Winston Fulton. (Courtesy Roy Bowman.)

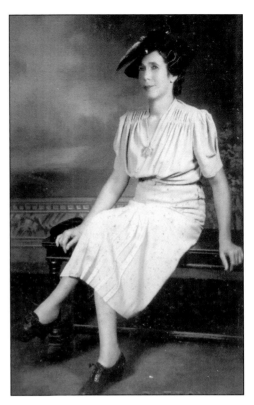

WILLIAM AND ETTA LOVE. William Edgar Love (1887–1987) and Etta Glenn (1882–1978) were married in 1906. They lived on their farm in Stokes County and reared nine children. Edgar made ax handles and caned chairs and wove baskets. Etta served the sick and elderly. She served as mother of the church and counseled members of the community. Etta saw seven generations in her family, the oldest being her grandfather. (Courtesy Levitha Mack.)

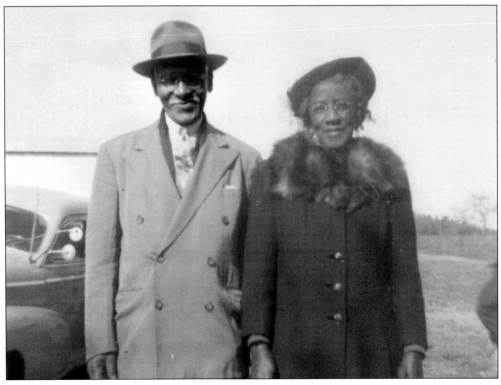

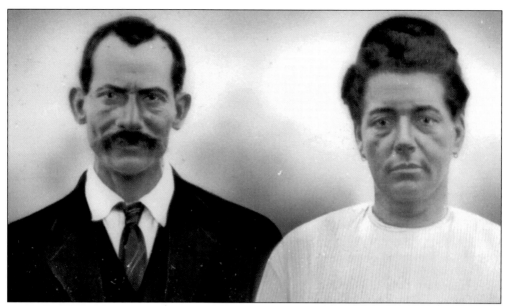

JAMES AND MARTHA DYSON DOBSON. James Lewis Dobson was born in 1871 in Rockford, North Carolina. His parents, Lewis and Caroline, were slaves on the Dobson Plantation. He married Martha Dyson, moved to Mount Airy, and built on land acquired from Robert Dyson, Martha's father. James could read and write, but Martha could only read. They had seven children. Lewis farmed, and Martha served as a midwife and made wine for church sacraments. (Courtesy Maggie Scales Rosser.)

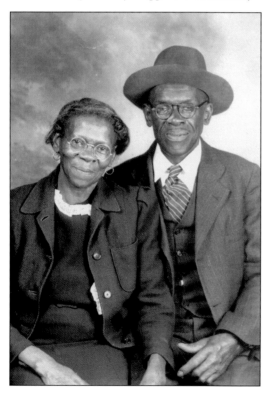

ROBERT AND IDA MCCARTHER. This picture was taken in 1945 for their youngest son, Nathaniel, who was serving in the military in Calcutta, India. Robert McCarther and Ida Frazier married and began their life together in Chestnut Ridge *c.* 1899. They developed a 93-acre farm. Their descendants celebrated the home and farmland as a historical site in 2003. (Courtesy Nathaniel McArthur.)

ROBERT "BUD" DYSON. Bud (1889–1963) was the son of Bob and Josephine Dyson. He married Mattie Mclain. They had no children and lived with his parents until his father moved to another house. Bud worked as a foreman at the granite quarry and janitor of the J. J. Jones High School in Surry County from the early 1940s until late 1950s. The students found his wisdom and advice a source of encouragement. (Courtesy Ronald Scales.)

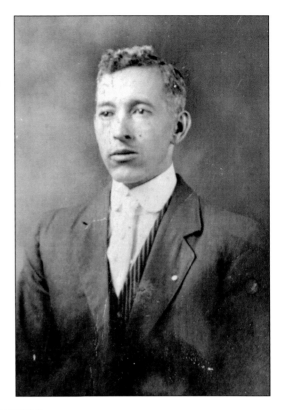

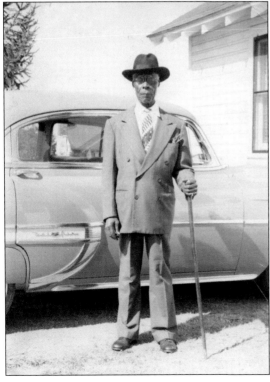

ERNEST ALLEN. This 1956 photograph was taken on Main Street in Dobson. Ernest was married three times and raised his grandson, Charlie Jarvis, after an early death of Charlie's mother. Ernest was a hired hand in tobacco farming and a maintenance worker for white families. (Courtesy Robena Jarvis.)

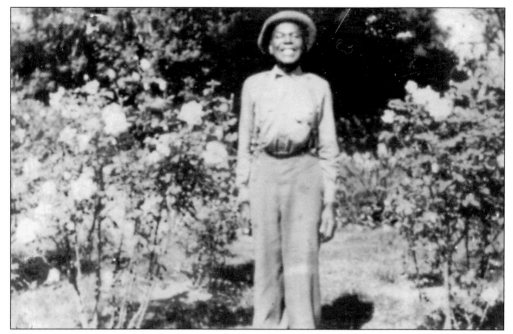

CHARLIE THOMPSON. Charlie worked for the Work Program Administration (WPA) for years. He also worked on a farm and at the granite quarry. Upon retirement, he worked part-time doing yard work for the Merritt family on North Main Street in Mount Airy. He was married to Nora Hughes. (Courtesy Edward McDaniel.)

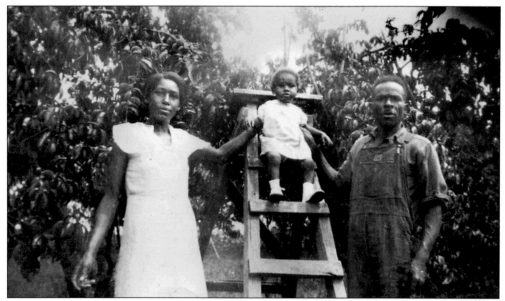

JAMES AND HESTER TAYLOR. James Taylor married Hester Hager. Here, they pose with daughter, Lucy Nora, in the peach orchard at their home on Wards Gap Road. James worked at Hines Lumber Yard. He grew a large family garden, and Hester preserved and canned the fruits and vegetables. Their harvest was always shared with members of the community. They reared a family of nine children. (Courtesy Lucy Nora Taylor.)

NEAL AND CORA TAYLOR SAWYERS. Neal was born in 1875 in Patrick County, Virginia. His parents were from the Soyears Plantation. Neal moved to Mount Airy and married Emma Fulton. They lived in a slave house on the Charlie Fulton property on what is now Riverside Drive. After Emma's death in 1918, he married Cora Taylor, pictured in this *c.* 1945 photograph. A farmer, Neal grafted trees and made flutes from sourwood for his 10 children. (Courtesy Adron Sawyers Martin.)

THEODORE AND KIZZIE CLARK. Theodore was born 1909 to Rash and Lue Clark in Westfield, Surry County. He married Kizzie Love in 1926. They were sharecroppers on farms in Surry and Stokes Counties. After rearing five children, Theodore worked in the tobacco markets in Winston-Salem and South Carolina until full retirement. (Courtesy Levitha Mack.)

DELLA MAE ARMSTRONG. Della Mae Armstrong (1889–1990) was a native of Wilkes County. She married Bill Sales at the age of 14. They had 16 children of their own, and Della helped to raise 27 children. (Courtesy Deborah Sales Bowman.)

JESSE AND SHERMAN DYSON. These brothers were the children of Fannie Dyson. Both grew up in Mount Airy and remained there, married, and reared families in the Ararat community north of the city. Both worked at the granite quarry. (Courtesy Roy Bowman.)

WILL THOMPSON. Will was one of several men from Pilot Mountain, Surry County, who left the area to work in the coal mines of Haveco, West Virginia. He did not return. This picture was taken *c.* 1920. (Courtesy Alphonso Tillman.)

LUELLA FRANCE. Luella married Harrison Jessup; they lived in Stokes County where they farmed tobacco, the money crop. Her grandson John Robert, dressed in his much desired army uniform, stands by her side in this *c.* 1940 photograph. (Courtesy Ella J. France.)

ESSIE SATTERFIELD. Essie and her sister, Mary, attended high school at Mary Potter School in Oxford, North Carolina, in 1937. After one year, they returned to the new high school on Virginia Street in Mount Airy. They were two of the three students who graduated from the 11th grade (the highest grade offered) in 1939. Essie married Weldon Joyce; they had two children. She was a domestic; Weldon worked in the congressional offices in Washington, D.C. (Courtesy Essie Satterfield Joyce.)

ERNEST AND VIOLA DOBSON. Ernest Dobson and Viola Tucker began their life together in the home of Ernest's parents, Jim and Martha Dobson. They inherited the family house with several acres of land. Ernest worked at the granite quarry, while Viola stayed at home with the children and her aging mother-in-law. This *c.* 1940 picture was taken in the front yard of their home. The remodeled Colonial home stands on Parker Road. (Courtesy Bernese Dobson Witherspoon.)

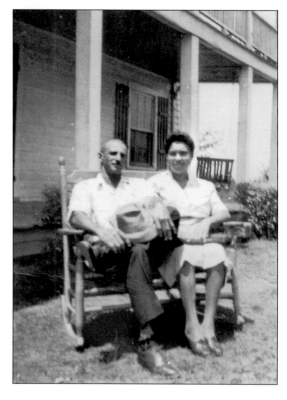

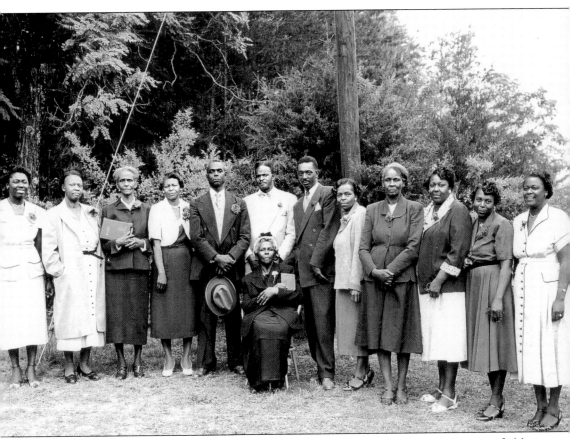

MINERVA COX. Minerva (1877–1981) was born on the Brim's Grove Plantation in Westfield to Eliza and Pete Jessup. At age 13, she married Bartley Woodrow Cox. She taught Sunday school until she was 87 and was a midwife and a healer. Minerva is pictured (seated at center) with 12 of her 15 children; from left to right are Julia, Odell, Zilla, Crissie, Roy, Graham, Gorrell, Zelma, Bertha, Alberta, Vara, and Bernice. (Courtesy Bernice Cox Lowe.)

MARY STELLA TRAVIS. Mary (born 1916) stands near her parents' home in Ararat, Virginia, where this *c.* 1932 picture was taken. Her parents were Rose and Walter Travis. She married Jesse David Tucker in 1933. They lived in the Pine Ridge community in Surry County where Mary lives today. They had three children: Ruby Lee, Jessie Mae, and Samuel Howard. (Courtesy Emma J. Tucker.)

COURTING. James Boston Tucker (1906–1978) and Rosa Lee Green (1920–1995) are getting to know each other in preparation for a life together. They married in 1935 and made their home in the Pine Ridge community where they reared six children: Edward, Charlie, Mae Alice, Emma Jean, Elaine, and David. James was one of the local men who made his living in a West Virginia coal mine. The mine closed in 1958. (Courtesy Rosa Tucker Opoulos.)

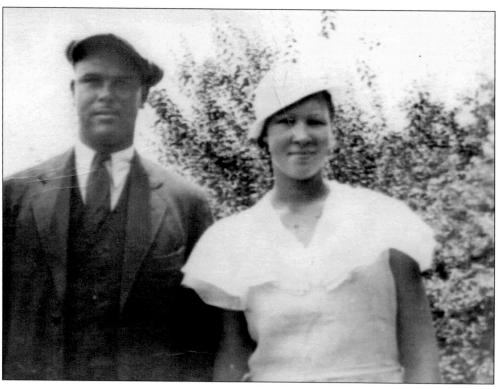

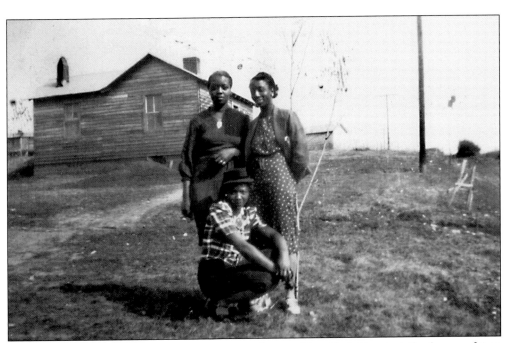

Ada Jackson. Ada visits with Evelyn Reeves and an unidentified friend at the home of Ann Jackson in Pilot Mountain *c.* 1940. Ada married Baxter Lovell, and they had three children. She worked as a domestic, while Baxter worked in a dry cleaning plant until he started his own cleaning business. Ada then worked with him in their business. (Courtesy Lydia Lovell.)

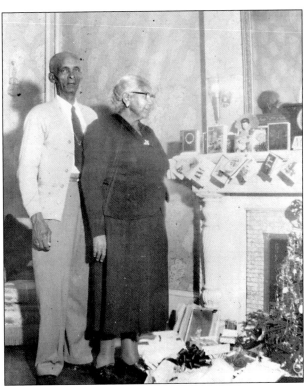

Willie and Vinnie Bowman. Willie was the son of Marsh and Pauline Bowman. Family history says that Vinnie Kimble was reared by a white family who brought her to Mount Airy from the mountains. She knew no siblings. Vinnie was an active person with the school and church. She shared stories with the children and was a strong force in the Ararat community. (Courtesy Sonya Dodd and Eva Bowman.)

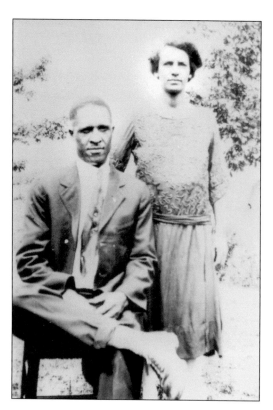

ERNEST AND DAISY HICKMAN. This portrait was taken *c.* 1919 early in the marriage of Ernest Hickman and Daisy Dobson. They built a home in Surry County on land given by Daisy's father, James Dobson. They had seven children. Ernest farmed and worked as a laborer at the granite quarry, while Daisy worked as a domestic. (Courtesy Maggie S. Rosser.)

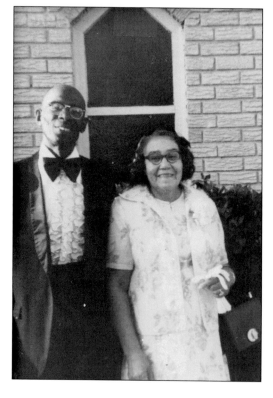

MILLARD AND OMELIA MCCARTHER. Millard McCarther married Omelia King in the early 1930s. Millard built a two-room log cabin on the farm in Chestnut Ridge, where they raised eight children. (Courtesy Nathaniel McArthur.)

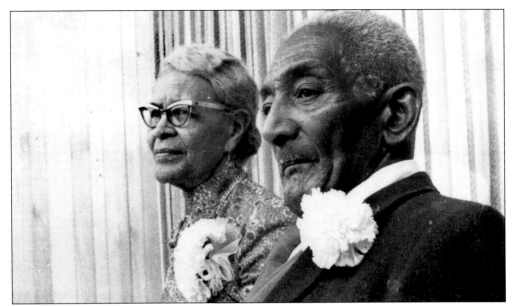

JAMES AND JESSIE RAWLEY. James Rawley married Jessie King in 1920 and they lived in a two-room, weatherboard house on Franklin Road in Surry County. The house had belonged to James's grandfather, Henry Copeney. James worked as a laborer at the granite quarry for 60 years. James and Jessie reared nine children. This picture was taken at their 50th wedding anniversary. (Courtesy Altin Reynolds.)

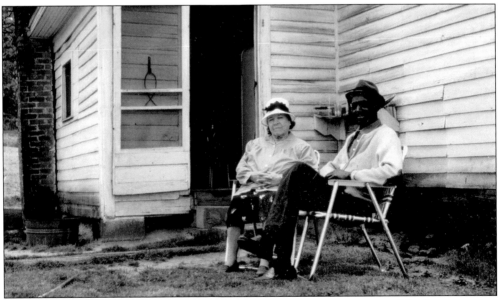

EDWARD AND SARAH PILSON. Edward Pilson (1900–1993) was born in Rockford. His mother worked at the Grant-Burrus Hotel where he helped by carrying water. Ed and Sarah Dyson began their married life in a log home in the Ararat community. In the 1930s, he sharecropped on the Chang Bunker farm with Chang's son, Albert. After Albert's death, Edward worked for Albert's daughter, Dottie, until his death in 1993. The two families remain close today. (Courtesy Sarah Pilson Moore.)

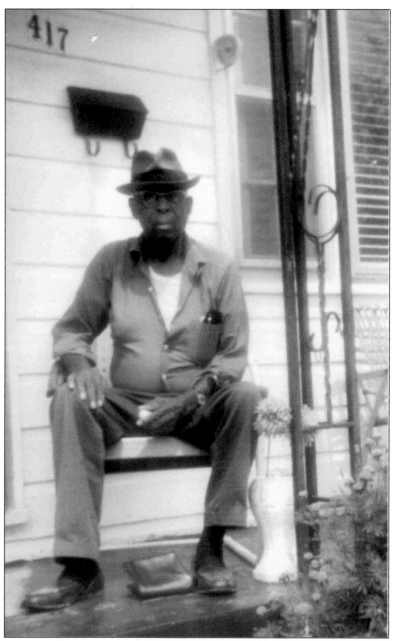

GEORGE CARTER. George (1898–1977) was born in Patrick County, Virginia. In 1920, he married Emma Qualls, whose father, Grant, was Native American. Grant told the story of white men purchasing slaves from across the mountain. When the white men arrived at the plantation, however, they learned the slaves had been freed and that they had lost their investment. While ministering to the sick during the influenza epidemic of World War I, George would take a drink of corn liquor to ward off germs before entering a home. On one occasion, he found everyone in the house dead. George worked as a bell hop at the Blue Ridge Hotel. George and Emma had seven children and lived with her mother in Nelson Hill. (Courtesy Charles Carter.)

The Thompson Family. Jennie married James Thompson. This 1949 picture shows her with the children, who are identified from left to right as Ernest, Catherine, Sybil, Syvilla, Rebecca, and James in her arms. She and the children farmed while her husband worked at Brown's Hatchery and tobacco markets. Jennie was honored as "Mother of the Year" by the Agriculture and Technical College in Greensboro, North Carolina, in 1950. She had two older sons in college at the time. (Courtesy Alphonso Tillman.)

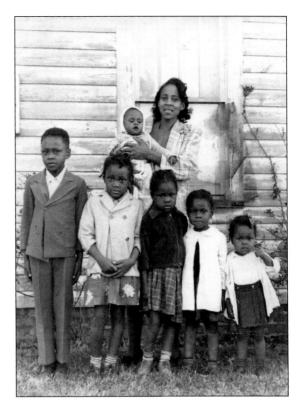

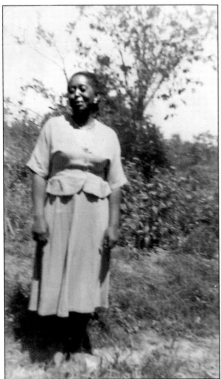

Zula Lovell. In 1900, Zula was born to John and Jean Joyce on the Joyce Plantation in Stokes County. Her father was eight years old when the slaves were freed. He remained on the plantation and attended school in Greensboro (now Bennett College); Jean attended a white elementary school in Stokes County. Zula married Sylvester Lovell, and this 1940 picture was taken in their Pilot Mountain home. (Courtesy Lydia Lovell and Alphonso Tillman.)

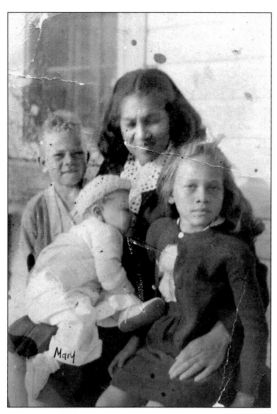

JETTIE HELTON AND CHILDREN. Jettie Forrest was married to Alton Helton. Their three children are shown in this 1946 photograph with Jettie; from left to right are James, Mary (on Jettie's lap), and Annette. (Courtesy Jettie Forrest Helton.)

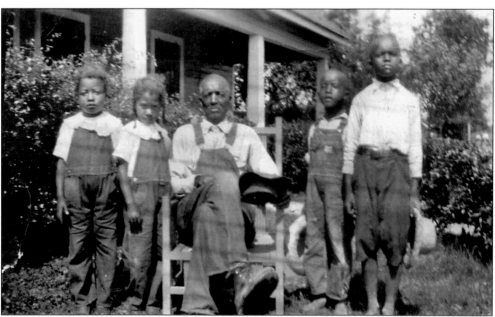

DOCK RAWLEY. Dock was married to Francina. This 1920s picture was taken in the Sandy Level community in Surry County. His grandchildren are visiting him on West Virginia Street. (Courtesy Josie Rawley Moore.)

THE TAYLOR FAMILY. Abraham Pannie Taylor (1898–1970) and Hallie Mariah Dyson (1900–1981) married in 1921 in Surry County. They had 11 children. The family farmed, and later Pannie worked at the granite quarry. After building a home in the State Line community, they bought the Charlie Thompson home in the Ararat community. The family moved to Stotesbury, West Virginia around 1929 where Pannie worked in the coal mines. (Courtesy Lucy Nora Taylor.)

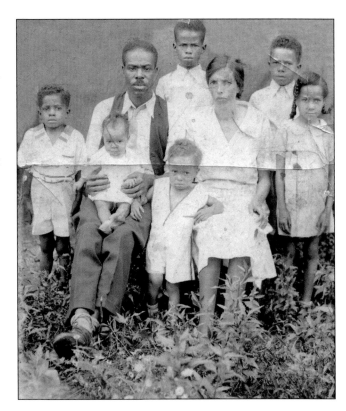

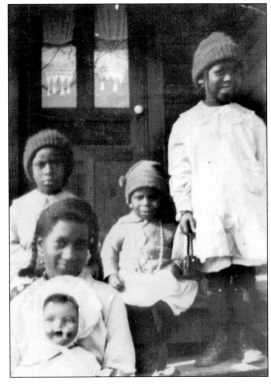

SAWYER CHILDREN. The children of Neil and Cora Sawyer in this 1927 photograph pose at the home place in Mount Airy. They are, from left to right, (first row) Alma, with doll; (second row) Dorothy, Leonard, and Vera. (Courtesy Adron Sawyer Martin.)

LUE HILTON (1859–?). Lue was born in Patrick County in the township of Stuart, Virginia, near the old Penn Store. She married Rash P. Clark, who lived in the same area. Later, they moved to the Asbury Big Creek community in Stokes County, purchased land, farmed, and reared nine children. (Courtesy Levitha Clark Mack.)

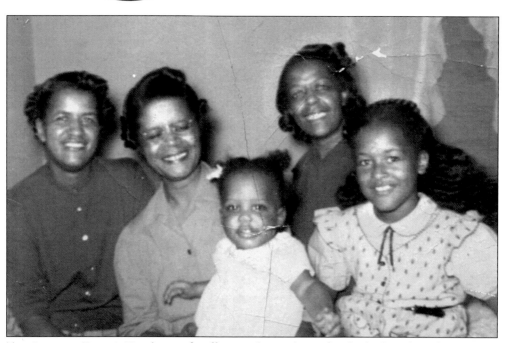

THE JOHNSON FAMILY. Members of Jeffery and Lutishie's family had gathered at Myrtle Johnson's home for a visit in this *c.* 1950 photograph. From left to right, they are Margaret, Myrtle, Marie, and Barbara Radcliff; the child in front is Bonnie. Myrtle lived in the Ararat community north of Mount Airy. (Courtesy Marie Johnson.)

CLAUDE GRAY AND EVA BOWMAN.
Claude Bowman (1919–1977)
married Eva Penn (born 1918)
in 1938, built a home in the
Ararat community, and raised
eight children. Claude worked
at two dry cleaning plants, a
wire company, and the granite
quarry. Eva was a presser in
the dry cleaning plant and a
domestic for the John Woltz
family for 33 years. (Courtesy
Eva Penn Bowman.)

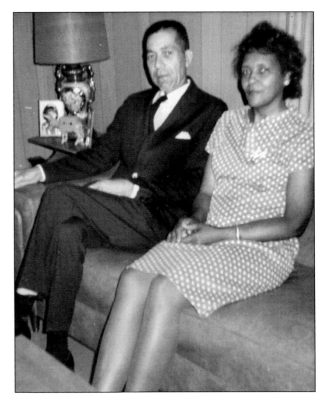

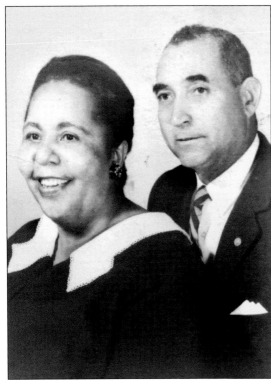

JESSE AND BEATRICE DYSON. Jesse Dyson
and Beatrice France married and lived
in the Ararat community in Surry
County. Jesse got his financial start
in the West Virginia coal mines. He
built their home with money he saved
and used his carpentry and masonry
skills to remodel the house. Beatrice
supplemented his income by working
as a domestic. Jesse served in World
War II, and they had four children.
(Courtesy Jesse Carol Dyson Patton.)

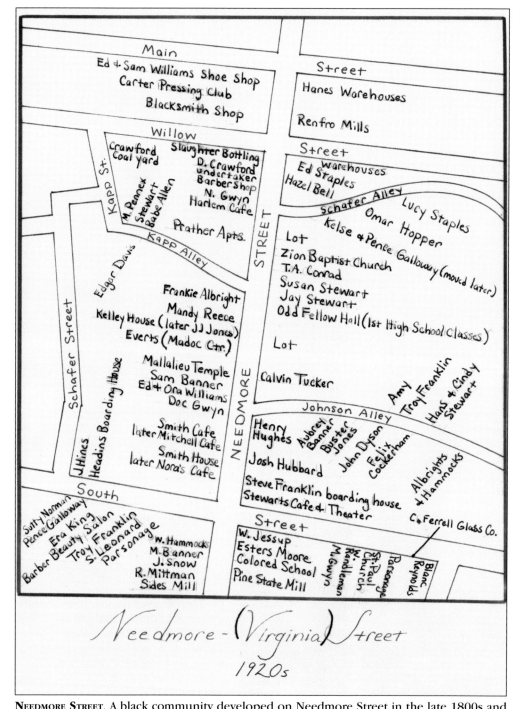

Main Street

Ed & Sam Williams Shoe Shop
Carter Pressing Club
Blacksmith Shop

Hanes Warehouses

Renfro Mills

Willow Street

Crawford Coal yard
Slaughter Bottling
D. Crawford undertaker
Barber Shop
N. Gwyn
Harlem Cafe

warehouses
Ed Staples
Hazel Bell

Schafer Alley
Lucy Staples
Omar Hopper
Kelse & Pence Galloway (moved later)

M. Pennex
Stewart
Babe Allen

Kapp St.

Prather Apts.

Kapp Alley

STREET

Lot
Zion Baptist Church
T.A. Conrad
Susan Stewart
Jay Stewart
Odd Fellow Hall (1st High School Classes)

Edgar Davis

Frankie Albright
Mandy Reece
Kelley House (later JJ Jones)
Everts (Madoc Ctr.)

Schafer Street

Lot

Mallalieu Temple
Sam Banner
Ed + Ora Williams
Doc Gwyn

Calvin Tucker

NEEDMORE

Amy
Troy Franklin
Hans & Cindy Stewart

Johnson Alley

Smith Cafe later Mitchell Cafe
Smith House later Nora's Cafe

Henry Hughes
Aubrey Banner
Buster Jones
John Dyson
Felix Cockerham

Albrights & Hammocks

J Hines
Headins Boarding House

Josh Hubbard

Steve Franklin boarding house
Stewarts Cafe & Theater

C. Ferrell Glass Co.

South Street

Suty Norman
Pence Galloway
Era King
Barber Beauty Salon
Troy Franklin
S. Leonard
Parsonage
W. Hammocks
M. Banner
J. Snow
R. Mittman
Sides Mill

W. Jessup
Esters Moore
Colored School
Pine State Mill

M. Gwyn
Randleman
St. Paul Church
Parsonage
Blanc Reynolds

Needmore - (Virginia) Street

1920s

NEEDMORE STREET. A black community developed on Needmore Street in the late 1800s and grew into a viable community with businesses, churches, schools, and social halls. This community was destroyed by urban renewal in the 1963. The street was renamed Virginia Street in the 1920s. (Courtesy James Penn.)

Three

CHURCH
Holding to Hope

All great people glorify their history and look back upon
their early attainments with a spiritual vision.

—*Kelly Miller*

*The Africans brought their own method of worship. They praised God with loud singing,
beating of drums, and marching. They sometimes worshipped secretly and quietly in the
fields and the bush. The masters favored a service of social interaction rather than one
of instruction because they believed leaders among the slaves a threat to the system. The
Northern crusade against slavery intensified the masters' fear of any gatherings. In order
to keep a closer eye on them, slaves were invited to attend church with their masters and
sit in the slave gallery. The attendance bordered on compulsion. The sermons were used
to indoctrinate slaves to be obedient and subservient to the master and mistress. During
the early 1830s, black preachers were prohibited from leading congregations on most
plantations in the South, so any black services were led by white ministers.*

*After the Civil War, colored people often continued to attend white churches in the
segregated gallery. Two churches that welcomed former slaves were Oak Grove Methodist
Church and Old Hollow Primitive Baptist Church. Churches were built in black settlements
of freed slaves during the last half of the 18th century. Here, the people were able to
worship in their own style. Spirited services used drums, hand clapping, shouting, praying,
and singing. Shouts of "well" and "Amen" encouraged the minister during the sermon. In
addition to Sunday service, some early churches were used as schools during the week.
Churches became places for social action and community events.*

—*Geneva Gee*

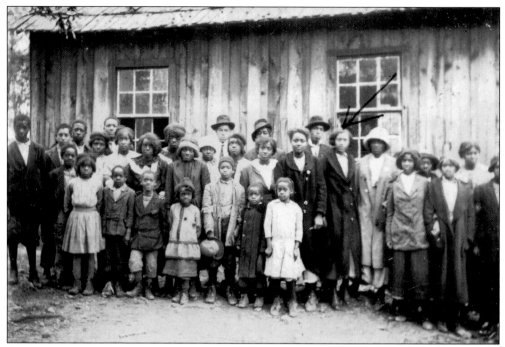

CHURCH GATHERING. In the early 1900s, members of Samuel's Grove Primitive Baptist Church gathered after a worship service in front of this weatherboard structure to have this picture made. The church was located in Patrick County, Virginia. Members came from North Carolina and Virginia to attend the church. (Courtesy Clarence Pilson.)

ELDER ROY COX. Roy Cox (1898–1983) married Della Hickman, and they reared 10 children. Roy's mother could be heard saying, "Lord, I've worn his body out; you've got to take his heart." It seems that Roy was a mischievous child. He joined the church at nine years of age. The lumber used to build the present building was donated from his farm. Reverend Cox later was the pastor of the church from 1944 to 1983. (Courtesy Bernice Cox Lowe.)

Elder James Scales. James (1855–1925) was born on the Scales Plantation in Patrick County, Virginia. His parents were Robert and Nancy. James married Mary Hill, and they moved to North Carolina where they reared a family of eight. He worked as a quarryman and as a grafts man. In the late 1800s, James was called to the ministry. He became the first pastor of State Line Primitive Baptist Church in Surry County in 1889 and served until 1911. A second marriage took James to Winston-Salem, where he died in 1925. (Courtesy Evelyn S. Thompson.)

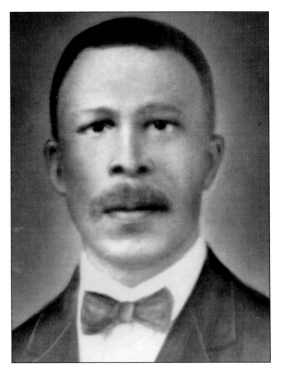

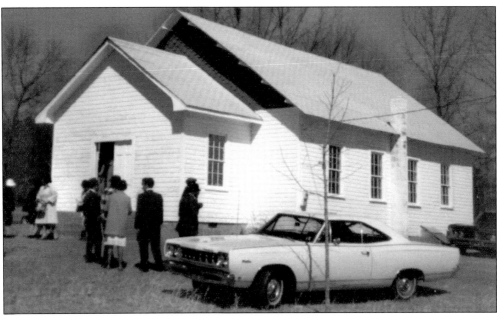

State Line Church. This Primitive Baptist church was organized in 1889. Early meetings were held on porches and yards of family members. Worship services were held once a month, and this schedule continues today. "Bob" Dyson deeded land to the church in 1928. The first pastor was James M. Scales from Patrick County, Virginia. Pastors held services in a different church each Sunday of the month. In 1960, the vestibule was added, and in 1976, a new church was built. (Courtesy Maggie S. Rosser.)

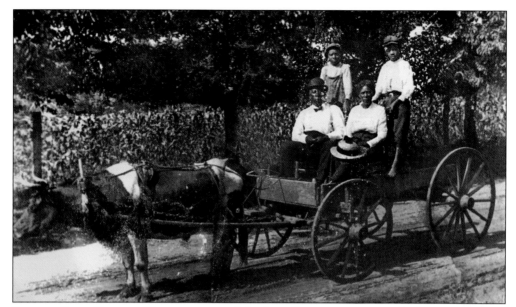

REVEREND JONES. Reverend Jones was one of the first African American Methodist ministers. He was taught to read by his slave master's son. His first church was in a brush arbor. He traveled by train from Lenoir, North Carolina, to Oak Grove Methodist Church in Elkin. Roxie, his wife, led the singing. This 1917 picture shows his sons meeting him at the Guilford County train station with a wagon pulled by Ol' Pounder, one of his oxen. Reverend Jones was minister to several churches in the area. (Courtesy Patricia Jones and the *Mount Airy News*.)

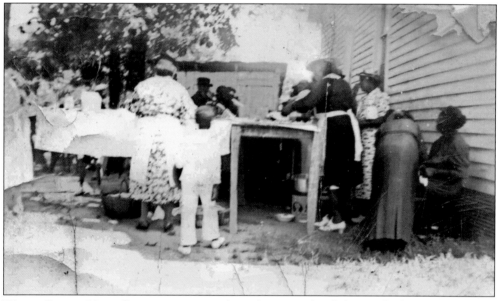

WESLEY CHAPEL. Many dinners were served on the grounds of this Methodist church in the late 1800s and early 1900s. The church was organized in 1891 in Elkin under the leadership of Rev. B. F. Thomas. The first church was built on North Bridge Street and rebuilt in 1903. In 1951, the present edifice was built on Oak Grove Road. The merger of Oak Grove Church and Wesley Chapel took place in 1949. (Courtesy Melvin Morrison.)

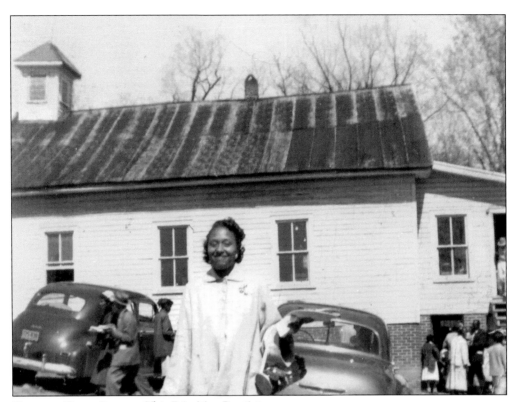

CHESTNUT RIDGE CHURCH. This Primitive Baptist church was built *c.* 1912 in Surry County. The land was donated by Fletcher Jessup; materials were donated by the community, and local men provided the labor. The first pastor was Rev. G. W. King. The second pastor was Rev. Roy Cox. A new edifice was built in 1965; Elder Joseph Scales preached the dedication sermon entitled "Wisdom Has Built a Church: Spread the Table and Invite the People." Olean Memphis Strickland is shown above. (Courtesy Bernice Lowe.)

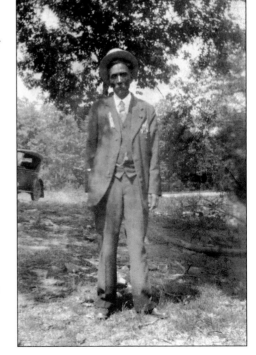

REV. GENTRY KING. This is a 1908 photograph of Reverend King. He served as the first pastor of the Chestnut Ridge Church. Once a month, he drove his Model A car from Stokes County to hold church service. He served 39 years and baptized 200 people. (Courtesy Bernice Cox Lowe.)

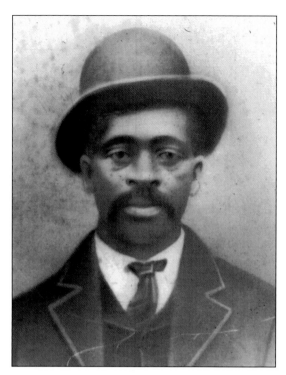

ELDER HENRY COPNEY. Henry migrated from Eden, North Carolina. He attended church at Old Hollow Primitive Baptist Church with whites and became the first pastor of the church given to black parishioners. Elder Copney was pastor at State Line Primitive Baptist Church between 1911 and 1913. He also pastored Locust Grove and Dry Hollow Primitive Baptist Churches. He was married to Eliza Jessup and died in 1941. (Courtesy Helen Rawley Taylor.)

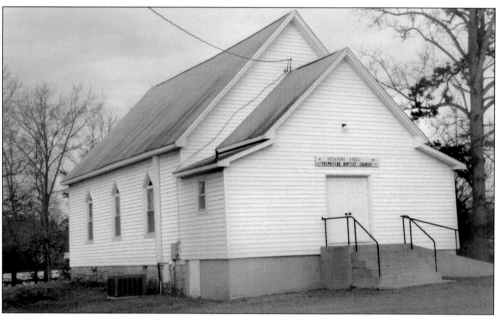

STEWART'S CREEK CHURCH. In 1794, black and white members worshipped in this Primitive Baptist church together. The rise of terrorism and Jim Crow laws created separatism, so whites built a new church; blacks remained in the log church until it burned. The present building was built by whites in 1904 for the black members. White members hold the deed to the property today. The first black minister was Henry Copney, who came from Eden, North Carolina, and attended church with the whites. (Courtesy Evelyn S. Thompson.)

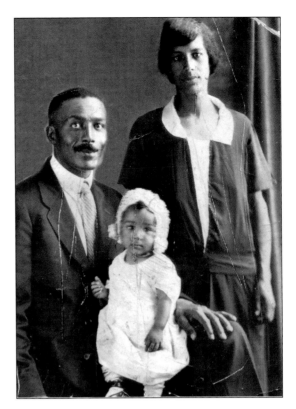

JOSEPH AND EMMA SCALES. Joseph Scales (1892–1970), son of James and Mary Hill Scales, married Emma Dobson (1894–1972) in 1915. He worked several jobs, including ones in the coal mines and rock quarry and as a farmer, carpenter, mason, and well digger. Between 1934 and 1964, he served the Primitive Baptist church. He pastored five churches, holding service at each once a month. He traveled by foot. Counseling, assistance, advice, prayer, and weddings took place in his home. Emma was the daughter of James and Martha Dobson. One of their 13 children, Maggie, sits on Joseph's lap. (Courtesy Evelyn S. Thompson.)

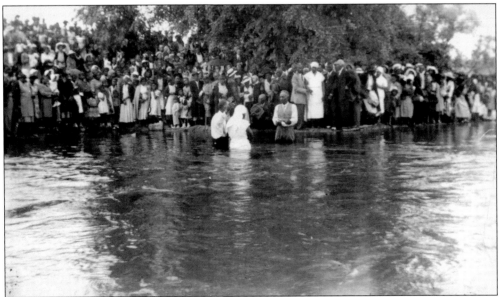

BAPTISM. New church members were baptized in the river or creek. Elder Joseph Scales, pastor of State Line Primitive Baptist Church, and Elder Andrew Taylor are baptizing a new member in Lovell's Creek *c.* 1949. The creek runs through the present Cross Creek Country Club in Surry County. Other bodies of water used for baptism were the Ararat River and Stewart's Creek. (Courtesy Maggie S. Rosser.)

ELDER WILLIAM FRANCE. William "Bill" France was born in 1863 to Moses Hatcher, a slave owner, and Judy, a slave, on a plantation in Patrick County, Virginia. He received his first cap from a Yankee soldier and learned to read by associating with those who could and by practicing with the Bible. Bill was married three times—each time after the death of his spouse. He had 20 children and was a farmer, carpenter, and blacksmith. With wages of 50¢ an hour, he saved enough to purchase two farms. Elder France pastored State Line, Blue Ridge, and Little Richmond Primitive Baptist Churches. He preached in an oak tree grove designated as "France's Stand" for many years before a church was built on the site. (Courtesy Strauder France.)

ELDER JESSE TUCKER. Jesse (1909–1996) married Mary Travis, and they reared three children in their home in Red Brush where Mary now lives. In 1948, Jesse was called to preach, and he was pastor at several churches, including Allegheny, Red Hollow, State Line, France Memorial Chapel, and Dry Hollow Primitive Baptist Churches. He retired in 1987. (Courtesy Mary Tucker.)

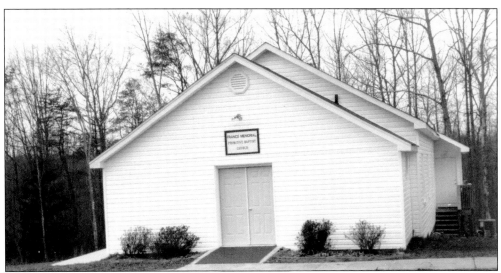

FRANCE MEMORIAL CHAPEL. This Stokes County Primitive Baptist Church was built in the late 1950s in memory of Elder William "Bill" France, who preached under the trees for years. The cinderblock building with vinyl siding was constructed by George Green, who donated time and materials. Recycled materials were used wherever possible. Church was held when there was a fifth Sunday in a month. People brought covered dishes that were served on planks nailed between the trees. They sat on tree stumps or planks or stood for the service. (Courtesy Strauder France.)

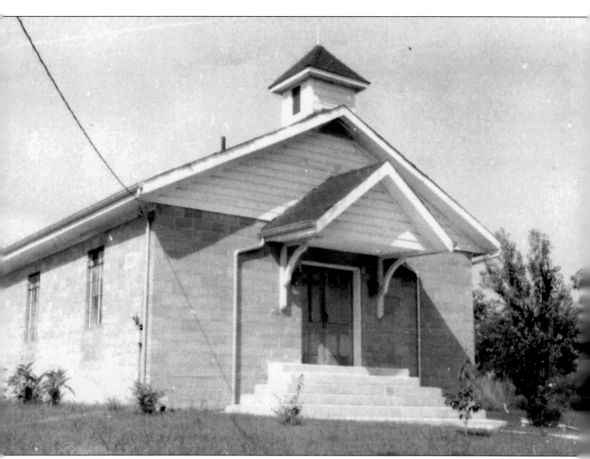

EDWARD WEBB CHURCH. In 1882, Rev. Gaston Catus organized the Colored Presbyterian Church on Catus Hill in Surry County. Rev. Thomas B. Hargrave succeeded Reverend Catus and led the effort to build a new church on Granite Street. In addition to the community support, Edward Webb of Oxford, Pennsylvania, gave a large some of money. The church was dedicated *c.* 1904 debt free and was named in honor of Edward Webb. In 1951, land was purchased on Worth Street, and dedication of a new church was held in 1954. Rev. LeGrande M. Onque was one of several pastors to serve. (Gladys Neal Bailey.)

REV. LEGRANDE ONQUE. Rev. LeGrande Onque came to Surry County from Princeton, New Jersey, by way of Mocksville, North Carolina, where he served the Presbyterian Church. He was the pastor of the Edward Webb Church from 1941 to 1951. During his tenure, the church grew in membership, had high enrollment in Sunday school classes, and had an actively participating missions program. (Courtesy Gladys N. Bailey.)

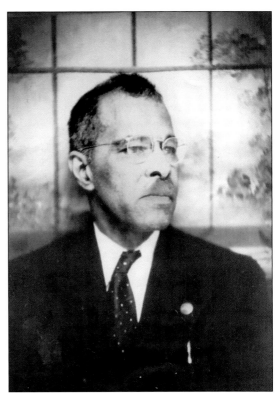

ZION CHURCH. This Baptist church was built *c.* 1895. L. T. Mittman served as pastor. The wood-framed church was later veneered with granite. It stood on Virginia Street in Mount Airy until 1963, the time of urban renewal. The church hosted the first planning meetings of the Surry County Chapter of the NAACP. Reverend Sloan was the pastor. In this 1929 photo, he is the second person from the left on the first row. (Courtesy Buster Jones.)

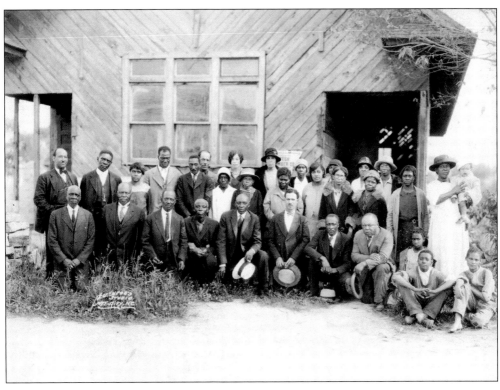

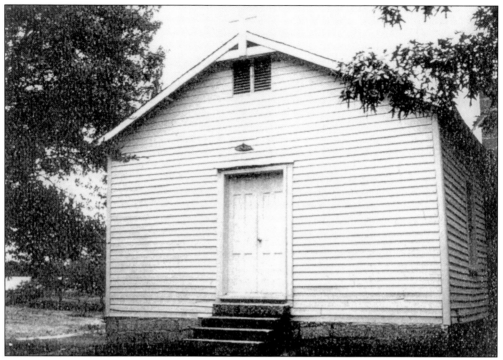

MOUNT CALVARY C.M.E. CHURCH, ORGANIZED c. 1899. This one-room log structure served as a school and church in the Oak Grove section of Combstown in Surry County. The first pastor was Rev. J. R. Turner. In 1917, the church gave half an acre of land to the State to build a school. The teachers were Henry Davie and Sally Kallam. A storm destroyed the school in 1919. The present church edifice was built in 1912. (Courtesy Perry March.)

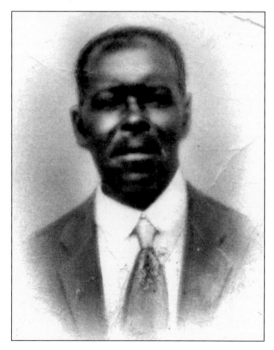

REV. FLETCHER JESSUP. When the Chestnut Ridge Church was built, Fletcher Jessup donated the land. He later joined and became a deacon and a preacher. He married Mary Hines, and they had ten children. After Mary's death, Fletcher married Maude Smith, a union that produced four more children. (Courtesy Bernice Cox Lowe.)

REV. JOHN PARSONS. This picture was taken in the yard of Gracie and Joe Dyson in Surry County's Ararat community *c. 1924.* Rev. John Parsons was the first pastor of the Ararat Missionary Baptist Church. The first church for blacks in old Ararat burned in the early 1900s. (Courtesy Gertrude McCloud.)

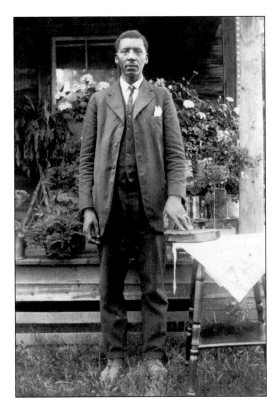

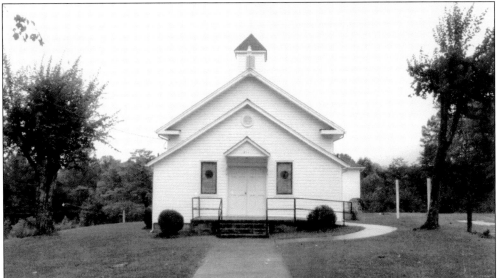

ARARAT MISSIONARY BAPTIST CHURCH. This church was organized in 1905. The first edifice stood in the old Ararat community in Surry County. The first pastor was Rev. V. A. Parks. In 1918, the church burned. One acre of land nearby was purchased from Solomon McCloud, and a new church was built. Rev. John Parsons became the new pastor. The church was located near the three-room school and utilized the training and expertise of the teachers. (Courtesy Edward McDaniel.)

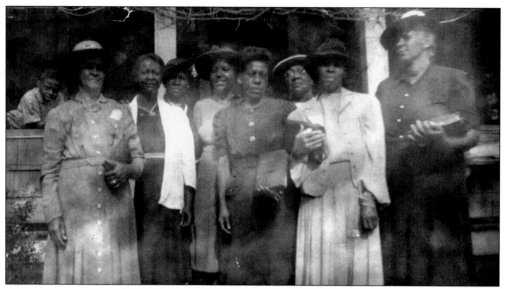

ARARAT MISSIONARIES. The Ararat Missionary Baptist Church missions circle was organized in 1929. Members sat with grieving families, gave food to and visited with needy families, collected money for burial for the needy, and instructed the young and new members concerning church policy. They also provided room and board for visitors attending the association meetings as hotels and restaurants were not available. This c. 1940 photograph shows, from left to right, the following members: (first row) Tishie Johnson, Delia Galloway, Mallie Satterfield, Nora M. Thompson, and Vinnie Bowman; (second row) Pauline Bowles, Ada Helton, and Gracie Dyson. The child is Jackie Bowles. (Courtesy Rosemary Dyson Green.)

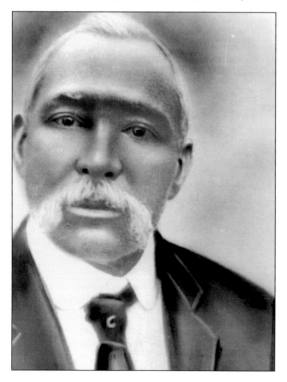

JESSE LOVELL. Jesse was born in 1850 on the Lovell Plantation in Stokes County to James Lovell, the plantation owner, and a slave woman. He married Lightfoot Pace, a Cherokee, and they had 12 children. Jesse, a carpenter, made and sold wagon wheels and ax handles. He helped to build Lovell Chapel, the first black Methodist church in Pilot Mountain. When the renovated log church was no longer usable, Jesse gave land for a new church, which has evolved into Lovell Chapel United Methodist Church. (Courtesy Lydia Lovell.)

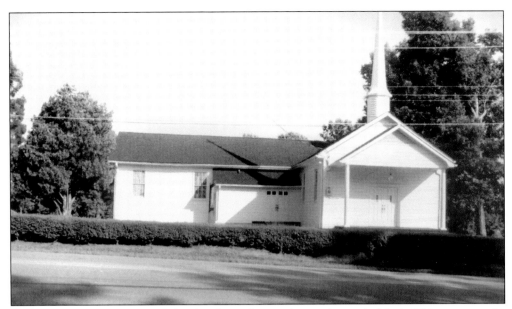

St. Homes Church. Many of the families who made up the early black Elkin community came from Devotion, North Carolina. The church there was named New Homes Baptist Church. As the people relocated, St. Paul and New Homes Baptist Churches merged. The merged church, St. Homes Baptist, stands on the grounds of the old Elkin School, which was purchased by James Hayes for the church. (Courtesy Evelyn S. Thompson.)

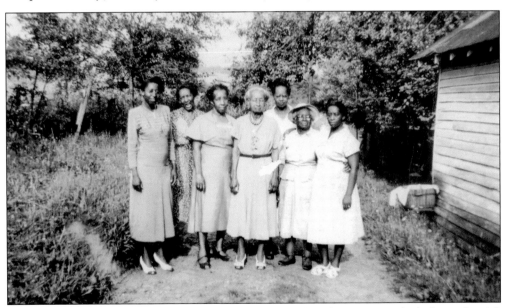

Lovell's Chapel Missionaries. These women served the church community by helping the sick and offering support to needy families. They reared many children of the community. When visiting their homes, they made sure children obeyed parents' orders. From left to right they are Mrs. ? Yarbrough, unidentified, Lonia Henderson, Lizzie Joyce, Ruth Cobb, Sara Joyce, and Zula Lovell. This picture was taken at Lovell's Chapel United Methodist Church in Pilot Mountain, Surry County, c. 1933. (Courtesy Alphonso and Prelette Tillman.)

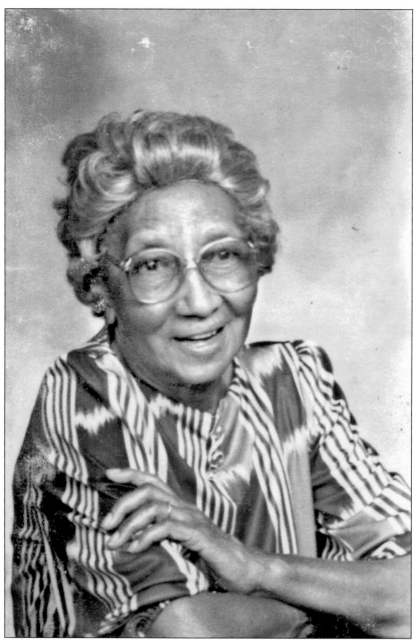

Rev. Sophia Joyce East. Sophia Joyce (1906–1996) was born in Pilot Mountain. She married Edison East, and they reared four children. As a member of Lovell's Chapel, she taught Sunday school, served as vice president of the Women's Society of Christian Service, organized the Methodist Men, and served as its first president. Reverend East was licensed to preach in 1958 and was ordained an elder in the North Carolina Conference of the Central Jurisdiction of the Methodist Church in 1964. She served in several churches. Under her leadership, two congregations built new sanctuaries, and two did extensive remodeling. Reverend East is featured in the book *Hope and Dignity: Older Black Women of the South* by Emily H. Wilson. (Courtesy Alphonso Tillman and Genevia Gee.)

PAYNE CHAPEL CHURCH. Pleas Payne gave land to build a community church. He worshipped with the Methodists, his wife was Primitive Baptist, and his daughter, Alice, was Pentecostal. He gave land with the understanding that the Pentecostals could hold services three Sundays a month, and the Primitive Baptists could hold services one Sunday a month. The present church was built in 1967; Rev. Marvin Lawson served as pastor. (Courtesy Bishop Tony Carter.)

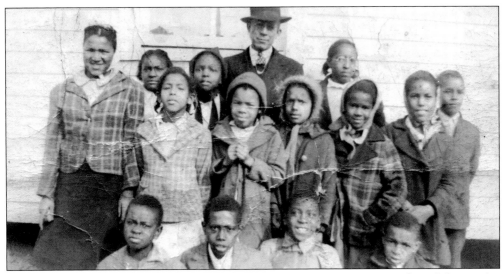

SUNDAY SCHOOL. This *c.* 1940 picture at the Ararat Baptist Church shows, from left to right, the following: (first row) Levi Galloway, unidentified, Lindburg Clark, and Robert Bowles; (second row) Marie Pilson, Polly Dyson, Clara Bell Whitlock, Mary Fulton Rawley, Tishie Bell Rogers, and Mildred Penn; (third row) Elizabeth Conrad, Lorraine Ferguson, Walter Bowman (teacher), Sarah Louise Rawley, and Allen Bowman. (Courtesy Roy Bowman.)

St. Paul A.M.E. Church. In 1898, Wayman's Chapel A.M.E. was organized. Rev. J. W. Walker was the first pastor. The church sat on the south end of South Street in Mount Airy. Under the leadership of Rev. Clifton Hodges, the chapel was sold and a new church was built on North South Street. The name became St. Paul A.M.E. Church. Redevelopment in the 1960s caused relocation to its present site on South Street. (Courtesy Buster Jones.)

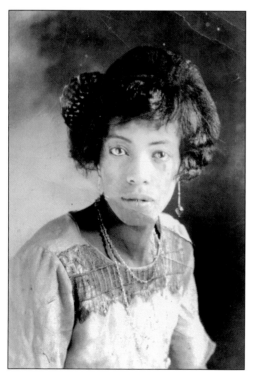

Rev. Mary Etta Matten. Reverend Matten was an evangelist and member of the Richough Church of God in Mount Airy. Her parents were George Johnson and Emma Tucker Johnson. She died in 1975 and was buried in the Tucker family cemetery. She had two surviving daughters, Cora and Etta. (Courtesy Emma Jean Tucker.)

70

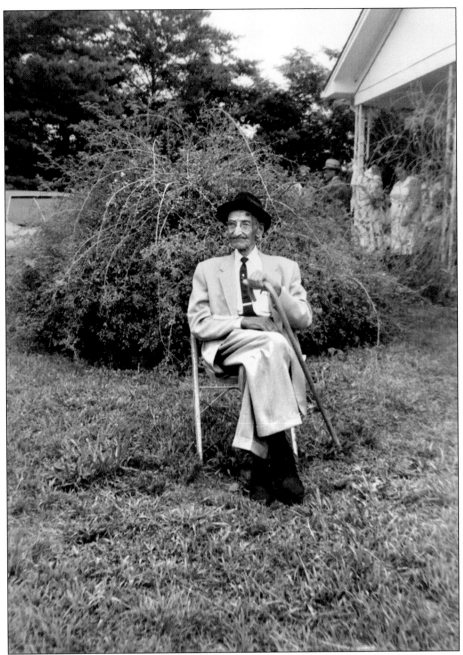

ELDER WILLIAM JACKSON ARNOLD. William Jackson was born 1875 in the Cross Roads section of Patrick County, Virginia. As a young man, he worked with his grandparents to clear and grub land. After they moved to Stokes County, he married Martha Jane Hughes and reared five children. Martha was a schoolteacher, and she taught Arnold to read, write, and compute arithmetic. After Martha's death, William married Lena Johnson in 1920. They had four children. He farmed and delivered merchandise for business in North Carolina and Virginia. His monthly $6 salary allowed him to purchase a horse and buggy as transportation for his family. William became a Primitive Baptist minister. (Courtesy Alice Jessup Brim.)

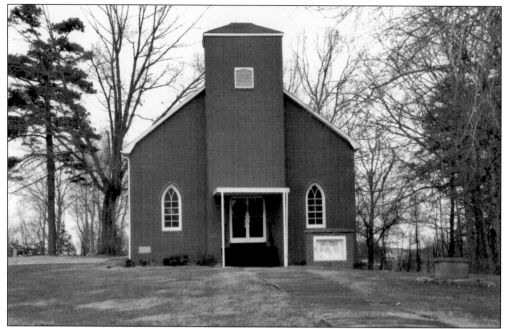

CLARK'S CHAPEL. This church, located on Barney Hill in Rockford, Yadkin County, was organized 1919 under the leadership of Rev. A. B. Clark. The building was constructed in 1923 under the leadership of Rev. P. Joyce. It was rebuilt in 1961 while Rev. G. W. Campbell served as pastor. (Courtesy Evelyn S Thompson.)

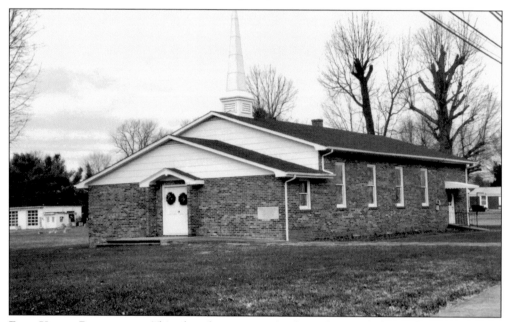

FIRST UNITED PRESBYTERIAN. This church was organized in 1872, and the edifice was built in 1888. It was rebuilt in 1976 after a 1972 fire and again in 1983. The modern brick church stands on the corner of State Road 67 and River Road in Boonville, Yadkin County. (Courtesy Richard Taylor.)

Four

EDUCATION
Upward Mobility

Our children must never lose their zeal for building a better world.
—*Mary McLeod Bethune, 1940*

Before the Civil War, slave owners refused to educate their Negroes, fearing that knowledge would lessen their domination. Laws were passed to prevent sympathetic people from teaching Negroes. Severe punishment threatened any slaves who revealed they could read or write. Despite the law, some slaves, especially house servants, learned to read and secretly taught others. Education was precious, and slaves knew the importance of learning.

After the Civil War, educated Negroes taught in churches and homes. Education beyond the most rudimentary level was nearly impossible for rural blacks. They were scattered in small groups and lacked the number of people necessary to support schools. Farm life demanded the children's help, so many could not attend school during the growing and harvest season.

Help came from the Freedmen's Bureau, the American Missionary Society, and several religious organizations by providing funds and teachers. In 1924, philanthropist Julius Rosenwald provided funds for the building of elementary schools. Because of segregation, a vast difference existed between public white schools and black schools. They were separate but not equal. In 1936, the first tax-supported black high school in Mount Airy was started on Needmore Street. Eventually, the school moved to the Ararat community and became J. J. Jones High School. Black students from three counties and parts of Patrick County, Virginia, were bused to Jones. In 1966, desegregation ended J. J. Jones as a high school.

—*Lucy Nora Taylor*

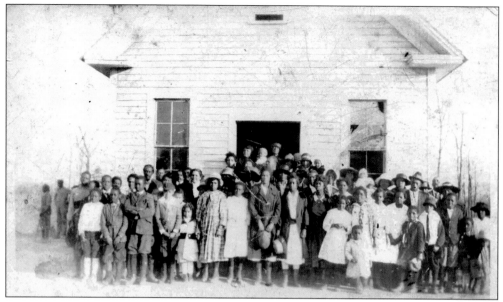

ELKIN ELEMENTARY SCHOOL. This photograph was taken in the 1800s in front of the school building in Elkin. It stood where the St. Homes Baptist Church is located today. (Courtesy Patricia Jones.)

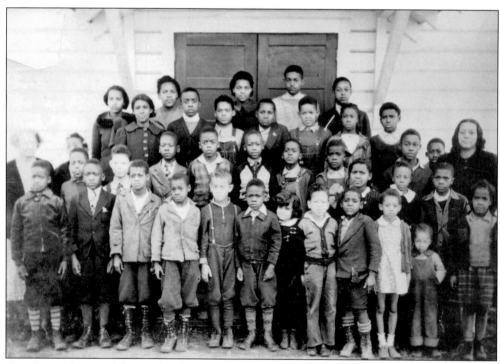

OAK GROVE SCHOOL. This 1949 photograph was taken at the Elkin Oak Grove Elementary School in Surry County. Mrs. Harris, third row on the right, was a teacher; the head teacher, Mrs. Mary Osborn, is in the fourth row on the left. (Courtesy Michael Stockton.)

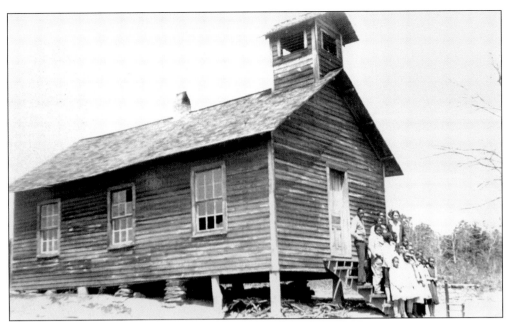

WILLIS GAP SCHOOL. This one-room, weatherboard elementary school was in operation in 1932 in Patrick County, Virginia. (Courtesy Patrick County Historical Museum.)

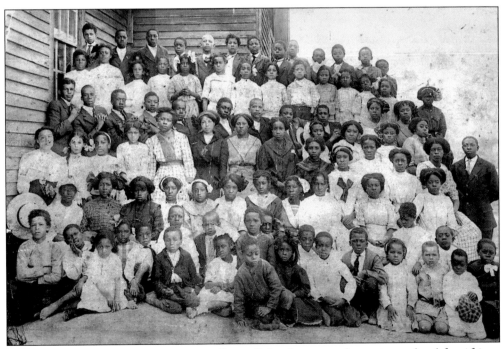

THE HAYMORE STREET SCHOOL. Haymore Street School was an elementary school for African American children in Surry County. Teachers Elbert and Roberta Harris are shown in this 1912 photo. Students came from Mount Airy and vicinity. The school later moved to Needmore Street (Virginia Street). (Courtesy Lucy Nora Taylor.)

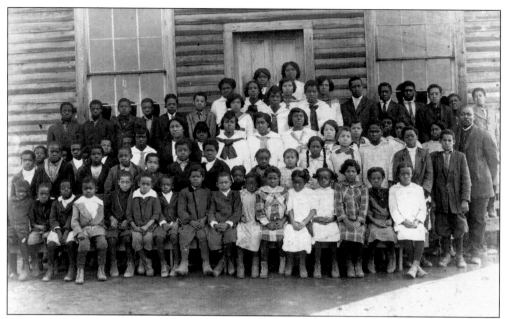

ARARAT COLORED SCHOOL. The students and teachers Rev. Albert Jenkins and wife, Ada, pose in front of the school in this 1916 photograph. The building was a two-room, weatherboard structure housing grades one through six. (Courtesy Lucy Nora Taylor.)

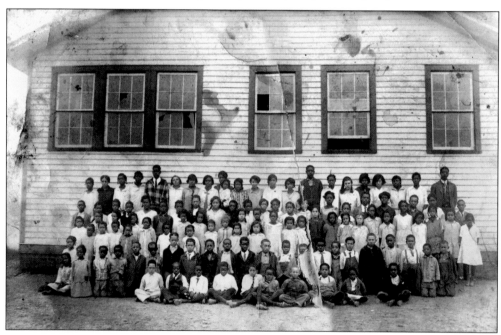

ARARAT COLORED SCHOOL, 1926. This Rosenwald School was built in the Ararat community in Surry County to replace the 1916 school. Julius Rosenwald provided grants to help communities across North Carolina and other states build schools. Ararat was a three-room, weatherboard building used until 1938 when it burned. The Mount Airy Colored School was built afterwards to house grades 1 through 12. (Courtesy Betty Rawley.)

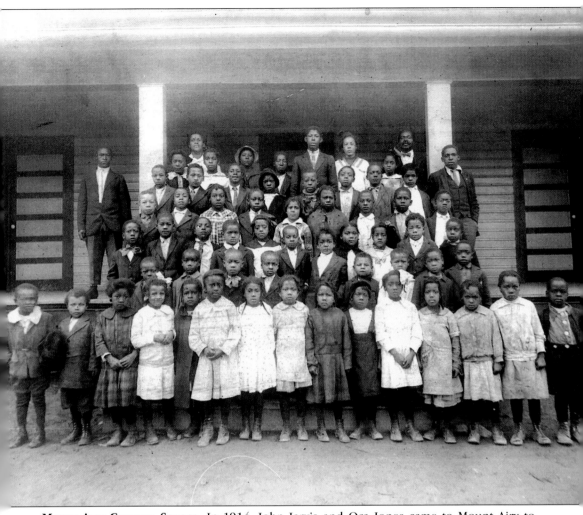

Mount Airy Colored School. In 1914, John Jarvis and Ora Jones came to Mount Airy to teach at the three-room, weatherboard school on Needmore Street (Virginia Street). John served between 1915 and 1933. After his death, his daughter Geraldine became principal and served until her brother, Leonidas, became principal in 1936. Other teachers included Lethia Revels, Kate Patrick, Steve Franklin, Fred Davis, A. L. Robinson, Emma Jean Jessup, and T. L. Williams. The school housed grades one through eight until 1938, when high school classes began in the dilapidated, two-story Odd Fellow's Hall on Needmore Street. When the hall was condemned, double sessions were held at the elementary school. Three students graduated from the 11th grade in 1938. Essie and Mary Satterfield and Clarastine Palmer attended their graduation exercise in Mallalieu Temple Methodist Church. The school operated until 1940. (Courtesy Buster Jones and Essie Joyce.)

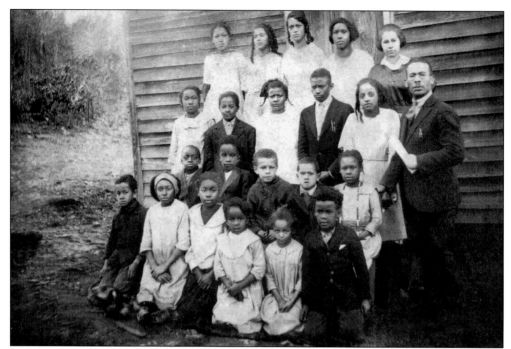

STONEY RIDGE CLASS. This *c.* 1920 photograph shows a teacher with students who attended the school. From left to right are (first row) Alfred Stewart, Mary Elizabeth Manns, Mabel Howard, Mary Stewart, Josephine Sawyers, and Paul Stewart; (second row) Rayford Manns, Vance Stewart, Adam Sawyers, Raymond Revels, and Helen Cundiff; (third row) Madge Howard, Clarence Sawyers, Rudy Gilliam, Randal Gilliam, Cora Sawyers, and Leroy Cundiff (teacher); (fourth row) Clara Revels, Sadie Sawyers, Lois Revels, Beatrice Revels, and Claudia J. Revels. The school offered grades one through eight. (Courtesy Mary Elizabeth Tatum.)

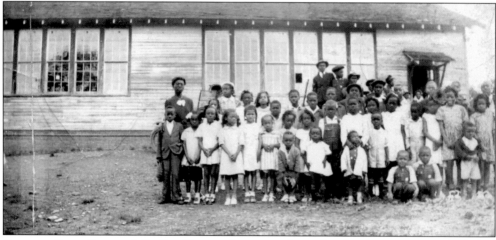

CHESTNUT RIDGE SCHOOL. Julia Cox Flowers began teaching after finishing seventh grade. She later graduated from Winston-Salem Teachers College, where she attended college free of charge. She taught first, second, and third grades at the Chestnut Ridge School for 40 years. Four teachers taught in the four-room Rosenwald School. (Courtesy Nathaniel McArthur and Bernice Lowe.)

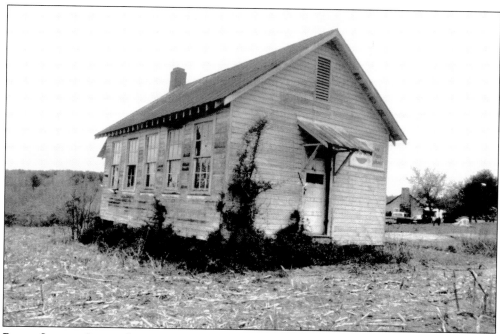

PISGAH SCHOOL, SECOND LOCATION, 1938. Mike and Ada Gentry donated land for Pisgah School after the first school burned. Children around Dobson, Surry County, attended this one-room, frame school. The following teachers taught there: Mrs. ? Morgan, Mrs. ? Hairston, Mrs. ? Ellis, Ms. ? Jefferson, and Ms. Fannie Phillips. The school housed grades one through eight. When the school closed, Fannie went with the children to J. J. Jones School. (Courtesy Surry Historical Society and Dewitt Dobson.)

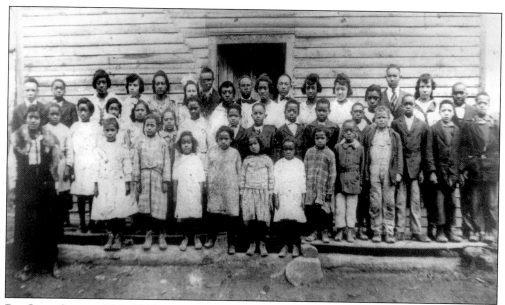

BIG CREEK SCHOOL. This 1918 picture was taken in Asbury, Stokes County. The school housed grades one through six. Molean Arnold, the teacher, is on the far left of the front row. (Courtesy Brahnall Dodd Wesley.)

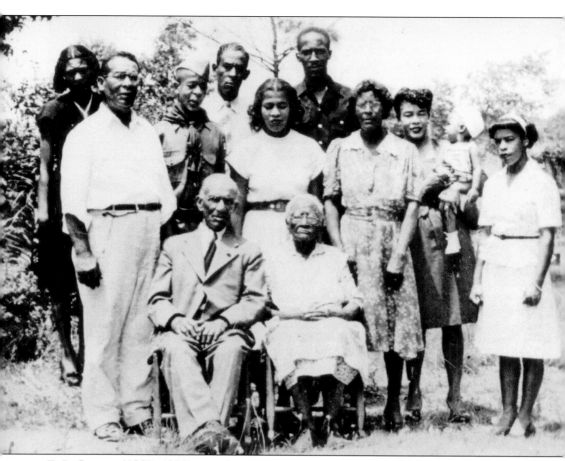

E. L. CUNDIFF (1897–1999). Emmett Leroy graduated from North Carolina Agricultural and Technical College in Greensboro in 1917. He married Treva Kimber and taught school in Surry, Stokes, and Yadkin Counties. Between 1921 and 1926, his salary was $75 a month; white teachers received $125. As a teacher and missionary, he served in South Carolina, Georgia, and Alabama with the Philadelphia Presbytery USA. Leroy was instrumental in establishing a high school for blacks in Yadkin County and was a charter member of Yadkin Valley Economic Development District, Inc. (YVEDDI), where he worked for 30 years. This 1948 photograph shows Leroy standing at left; his wife is third from the right. Leroy's father, William, and Treva's mother, Laura Kimber, are seated. The others are his children, their spouses, and his grandson, Steve. (Courtesy Steve Greenlee.)

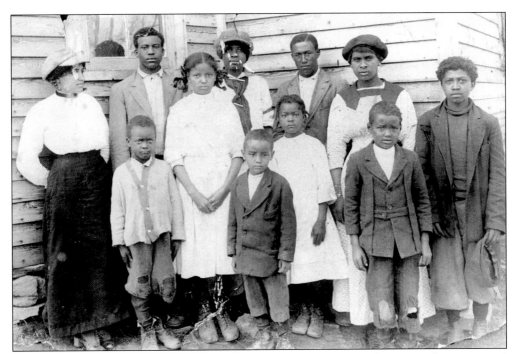

SILOAM SCHOOL. Otie Scales was the teacher at this school in the early 1900s. She is pictured at far right. In 1916, she married the student next to her, Robert Kellam. They had four children. In 1976, they celebrated 60 years of marriage. (Courtesy Yvonne W. Lovell.)

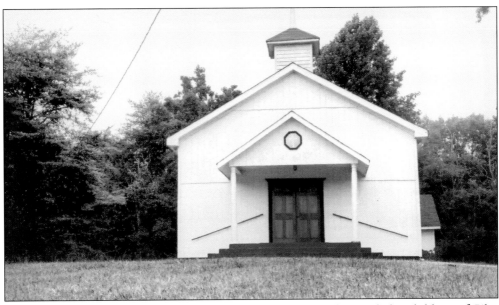

PILOT MOUNTAIN ELEMENTARY SCHOOL. This one-teacher school served the children of Pilot Mountain before schools were consolidated. There was a small office for teachers, a potbelly stove, and a well in the front yard. The large playground provided ample space for the children of the first through seventh grades. The building now serves as a church. (Courtesy Alphonso and Prelette Tillman.)

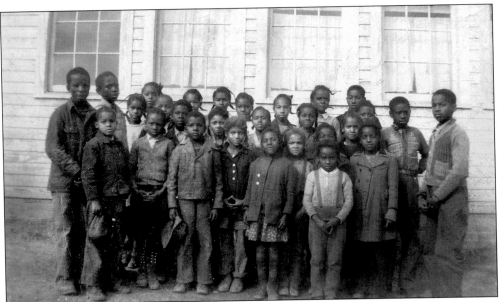

PINNACLE SCHOOL. This school housed grades one through eight. The students included in this *c.* 1939 picture are Mary Lee Taylor, Olene Dodd, Evelyn Tatum, Frances Dodd, Polly Penn, Frances East, John L. Dobson, Bernie France, John D. Taylor, Clarestine Penn, Christine Tatum, Lillie Mae Reynolds, Hurlda Reynolds, Virginia Dodd, Betty Lou East, Faye Taylor, Althea Taylor, Martha Ruth East, Louis Dodd, and John L. Penn. (Courtesy Christine Tatum Porter.)

SANDY LEVEL SCHOOL. This framed three-room school was built *c.* 1923 with the Julius Rosenwald Fund and money raised by the community. The school housed grades primer (pre-first grade) through sixth. It was heated with coal-burning potbelly stoves, used a well for water, and had outside toilets. Children walked home for lunch or brought their lunch. A hand bell gathered and dismissed the students. (Courtesy Lucy Nora Taylor.)

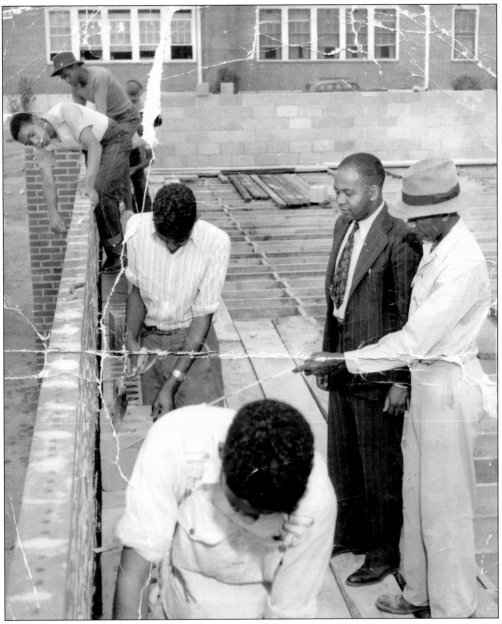

THE GYM. E. T. Sellars directed the construction of the J. J. Jones High School gymnasium in 1947. The community raised $2,000, and the board of education gave $4,000. Some lumber was salvaged; some was purchased from sawmills. An automobile dealer donated rock. E. T.'s students broke the stones and used their training in "trowel trade" for constructing walls. The classes made cement blocks for the foundation and laid the brick. The work by students and community members saved thousands of dollars in labor costs. At its completion, the estimated value of the building was $30,000. The main floor measured 88 feet by 55 feet. (Courtesy Edward McDaniel.)

PAYNETOWN SCHOOL. This Rosenwald School was built in 1925 with two rooms on land donated by Pleas Payne. The teachers, Sallie Hairston and Josephine Massey, boarded with Pleas and Martha Payne in the neighborhood. The school was renovated and is used as a church. (Courtesy Bishop Tony Carter.)

FANNIE PHILLIPS GENTRY. When Fannie grew up in the early 1900s, there was no high school for black students in Surry County. She graduated from Atkins High School and Winston-Salem Teachers College. She taught 11 years at Pisgah School, which had grades one through seven, in Surry County. She had about 23 students. She recalled fondly how close the parents and teachers were, that there were no discipline problems, and that most students walked to school. (Courtesy Fannie P. Gentry.)

MOUNT AIRY COLORED HIGH SCHOOL. This school was established in 1939 as the first consolidated black school in Surry County. Leonidas H. Jones was appointed principal. It was later renamed J. J. Jones High School in honor of the principal's father, who had served the school on Needmore Street (Virginia Street). Leonidas remained principal until it became an elementary school during desegregation in 1966. The school, which housed grades 1 through 12, catered to students from Stokes and Patrick Counties. J. J. Jones High School was the only high school in Surry County for African American students. (Courtesy Lucy Nora Taylor.)

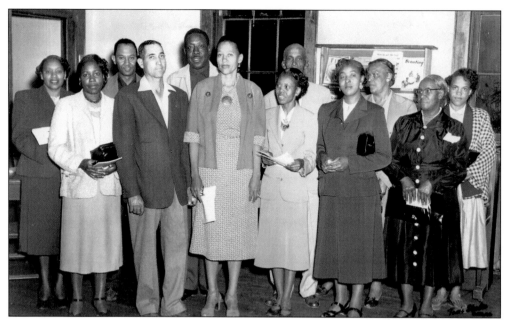

PARENT TEACHER ASSOCIATION. This 1950 photograph was taken in the auditorium/library at J. J. Jones High School. The group met monthly to address school issues such as lighting, textbooks and supplies, buses, water, and sewage. The members, from left to right, are as follows: (first row) Annie Bell Long, Jesse Dyson, Leone Cannon, Virginia Galloway, Hattie Whitlock, and Gracie Dyson; (second row) Alice Rawley, Buster Jones, unidentified, Willie Bowman, Mabel Allen, and Josephine Travis. (Courtesy Gertrude Bowman McCloud.)

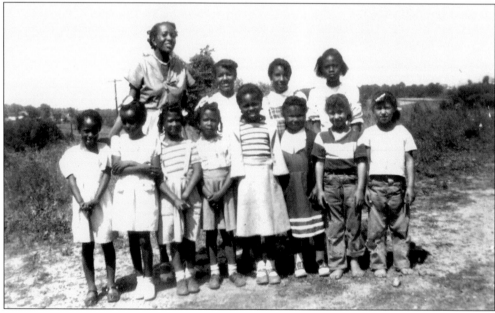

L. D. YARBROUGH'S CLASS. Ms. Yarbrough poses with her class of 1948 at the Pilot Mountain Elementary School. This one-room school had no modern conveniences. (Courtesy Alphonso Tillman.)

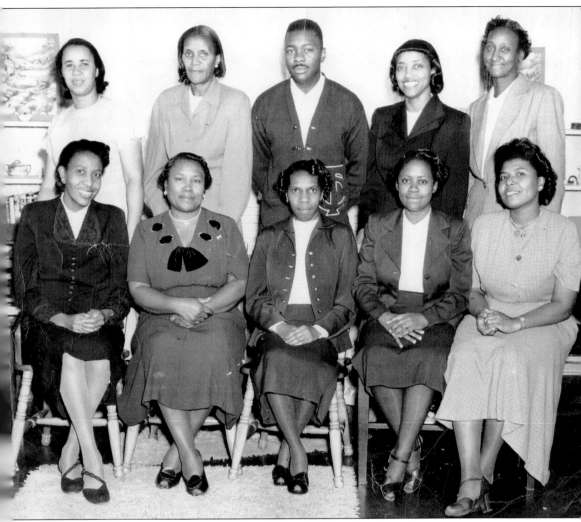

WSTC Alumni Club. The Surry County Winston-Salem Teachers College Alumni Club operated from 1950 to 1965. The club gave some students the only chance they had to earn a college degree. Fund-raisers included a series of one-act plays and baby contests. Scholarships of $100 were given to students of their choice. Students who received scholarships to Winston-Salem Teachers College were as follows: Charles Thompson, 1949; Magdalene Moore, 1950; Clarastine Penn, 1951; Cathleen Cox, 1952; Hazel Dobson, 1952; Evelyn Scales, 1953; Catherine Thompson, 1954; Barbara Penn, 1955; and Otha McCarther, 1956. The alumni club members pictured in this 1950 photograph from left to right are (first row) L. D. Yarbrough, Janie Thomas, Gladys Neal, Johnnie I. Johnson, and Loris Gwyn; (second row) Emma Galloway Edwards, Beulah Onque, Carl K. Hargraves, Wilveria DeLaine, and Laura Sue Johnson. Other members included Josephine Massey, Fannie Gentry, Julia Flowers, Bernice Cox, and Verdie McClinton. (Courtesy Gladys Bailey.)

L. H. JONES. Leonidas Harold Jones followed his father as teacher/principal at the Mount Airy Colored School on Virginia Street. He was appointed principal to the new Mount Airy Colored High School in the Ararat community where he served the 26 years. He married Eleanor Sellars, who worked with him in several capacities, and they reared two children. Leonidas held other leadership roles in the community. (Courtesy Evelyn S. Thompson.)

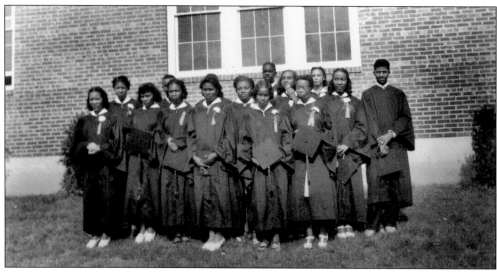

GRADUATES, 1941. This was the first graduating class from the new Mount Airy Colored High School located in the Ararat community. They were graduating from the 11th grade; the 12th grade was added the following year. The principal and class adviser was Leonidas Harold Jones. The class consisted of the following students: Maryreign Cox; Ollie Taylor, secretary; Margie Kellam; George Howard; Katherine Gwyn; Mary Carter; James Strickland; Sadie Strickland; Dora Taylor; James Dobson; Helen Rawley; Kathleen Thompson; Naomi McCloud, president; and Margie Whitlock, treasurer. (Courtesy Lucy Nora Taylor.)

L. S. Johnson. Laura Susan Johnson came to Surry County from Summersville, North Carolina, in the 1930s. She taught at the Ararat Colored School, built with Rosenwald funds, until the school burned in 1938. She then taught at the Mount Airy Colored School on Virginia Street. When split sessions were held, Laura served as principal of the morning elementary school, while Leonidas Jones was principal of the afternoon high school. Laura boarded with different families in the community until 1966. (Courtesy Maggie S. Rosser.)

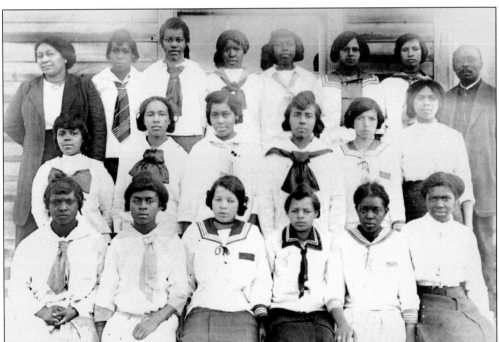

Class of 1916. This is a 1916 sixth-grade graduating class, the highest grade taught in Surry County for colored students at that time. This school was located in the Ararat community. Rev. Albert and Ada Jenkins were the teachers. (Courtesy Lucy Nora Taylor.)

BOONVILLE HIGH SCHOOL. The first high school in this area was built in 1942 with B. T. McCallum as principal. Emmett Leroy Cundiff gave the land for the building. The first commencement service was held in 1945. The Yadkin Valley Economic Development District, Inc. (YVEDDI) now uses the building, since the school was relocated. (Courtesy Nora D. Penn.)

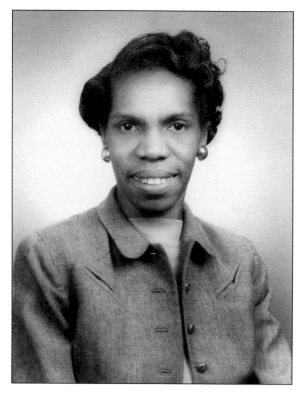

GLADYS NEAL BAILEY. Gladys and her parents came to Surry County from Oklahoma. In 1944, she taught grades one through four at the Westfield two-room school. In 1948, she taught grades one through three at the Sandy Level three-teacher school. She then taught grades six and seven at J. J. Jones School from 1950 until 1966. Gladys has served in many leadership capacities in government and in the Edward Webb Presbyterian Church. (Courtesy Gladys N. Bailey.)

90

Five

WORK
Making Our Way

Respect those who work hard . . . warn the idle, encourage the timid,
help the weak, be patient with everyone.
—*Thessalonians 4:12–14*

Mount Airy began as a plantation. People of African ancestry were brought here to build a viable economic system based on agriculture. Some Africans brought important skills with them, such as carpentry, blacksmithing, bricklaying, and farming. Many skills were learned on the plantation, whether in the field or in the household. Women were valued according to their ability to give birth to children. Rearing children on the plantation was important. Young, healthy, and strong men were choice.

The 13th Amendment ended slavery. During the struggle for independence, ex-slaves put their skills and knowledge to work building their own neighborhoods. Some were given land by slave owners; others purchased land. Sympathetic whites helped them skirt discrimination practices. They depended on each others' skills, abilities, talents, and knowledge to build new lives. Special skills were traded. During the 18th and 19th centuries, most families farmed as owners or sharecroppers. Some found employment in the coal mines and the railroad. After 1889, many men worked at the granite quarry as stonecutters, water boys, messengers, supervisors, and machine operators. Women were domestics and child-caregivers for white families.

In the early 1900s, the entrepreneurial spirit rose and businesses popped up in various neighborhoods: grocery stores, cafés, barber and beauty shops, undertakers, wood sellers, butchers, carpenters and masons, dry cleaners, shoe shops, boarding houses, and hauling enterprises. Preachers, midwives, and teachers were highly respected by the people.

—*Eunice C. Jessup*

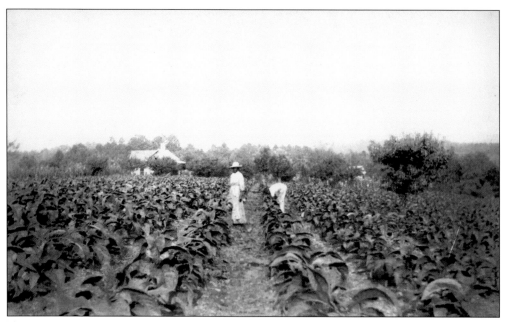

THE CLARK FARM. George Washington and Amanda Watkins Clark came to Surry County from the Clark Plantation in Stuart, Virginia, in 1909. After sharecropping on the Fulton Plantation for several years, they were able to purchase land, build a home, and develop their own farm. This 1914 picture shows the Clarks' farm and home in the background. In 1917, additional land was purchased to enlarge the farm. (Courtesy Lucy Nora Taylor.)

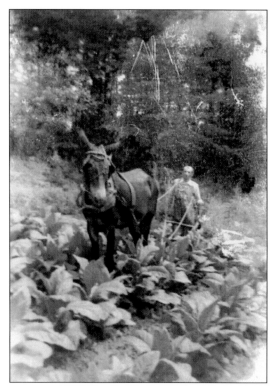

FARMING. This c. 1955 photograph of Ernest Gwyn is a reminder of what farming and gardening was like before farm machinery. Here, Ernest plows between the tobacco rows to control weeds. His farm was located in Dobson, Surry County. (Courtesy Kathy Hunt Dobson.)

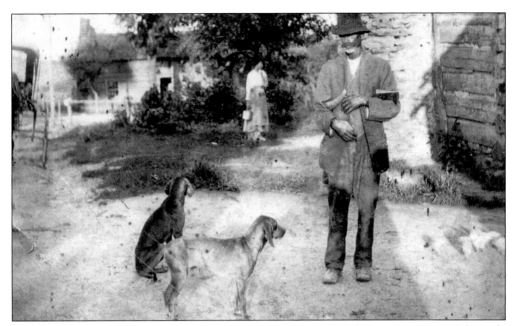

JOHN MARSHALL BOWMAN (1851–1919). John was born in Patrick County, Virginia, the only son of Sarah and Jim Coleman. Sarah was Cherokee and Jim was white. Marsh married Pauline Greenwood in 1881 in Mount Airy. He farmed, and Pauline was a "wash woman." Some of the Bowman's eight children went out of town to receive higher education than the fifth grade, which was all that was offered by the local school. (Courtesy Roy and Juanita Bowman Tatum.)

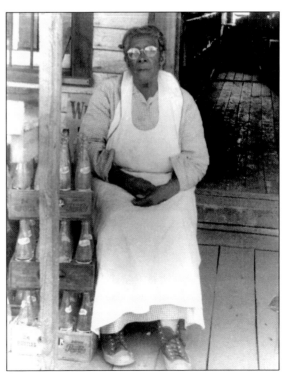

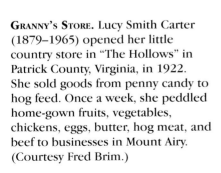

GRANNY'S STORE. Lucy Smith Carter (1879–1965) opened her little country store in "The Hollows" in Patrick County, Virginia, in 1922. She sold goods from penny candy to hog feed. Once a week, she peddled home-gown fruits, vegetables, chickens, eggs, butter, hog meat, and beef to businesses in Mount Airy. (Courtesy Fred Brim.)

THE MILL. When farms failed, some men, women, and children went to work in textile mills or tobacco factories for low wages. Lucy Dobson Pearson (born 1854) is one of the workers in this photograph. She owned a home in the State Line community, now Parker Road. (Courtesy Emma Jean Tucker.)

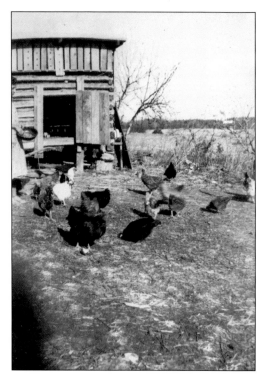

FEEDING CHICKENS. In the 1930s, families raised much of their food. Emma Dobson Scales is shown feeding her chickens. She sorted eggs for hatching and eating. Chickens were fed corn, crumbled corn bread, and mash. The chickens lived in the house in the background with a fence to keep them in and other animals out. (Courtesy Maggie S. Rosser.)

(Above, Left) **MINNIE JONES STEWART.** Minnie walked along Kapps Alley near Needmore Street (Virginia Street) to go to work in the home of a white family. The house in the background belonged to Calvin Tucker, a prominent businessman. Minnie is the mother of Buster Jones. (Courtesy Malachi "Buster" Jones.)

(Above, Right) **CARRIE SAWYERS (1895–1975).** This 1915 photograph was taken in Winston-Salem when Carrie stayed and worked with a white family. She was married in her home county of Patrick in 1917 to Early Roberts (1892–1979). They farmed and were devout church members of Samuel's Grove Primitive Baptist Church. They raised a family of six. (Courtesy Frances Roberts Brim.)

THE NANNY. In the late 1920s and early 1930s, Jessie Herring worked as a domestic. Here she is taking care of Sabrina, a child of the family for whom she worked in Mount Airy. (Courtesy Ernestine Herring Reynolds.)

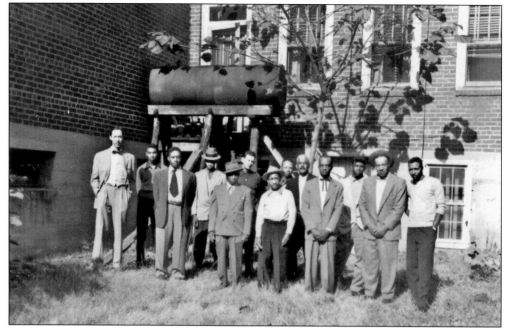

BROWN HATCHERY. This 1953 picture shows some of the men who worked at Brown Hatchery in Pilot Mountain. They received about $46 a week in wages. The hatchery tasks included grading eggs for hatching, washing egg trays, unloading supplies, boxing and loading chickens, and taking blood tests of chickens. (Courtesy Alphonso and Prelette Tillman.)

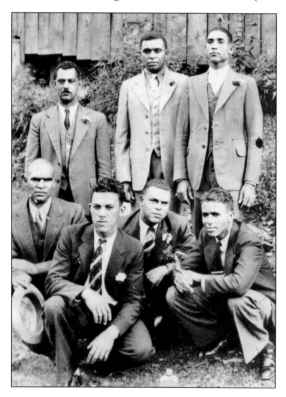

MINE WORKERS. In the 1920s and 1930s, many men from the Surry County region went to West Virginia to work in the coal mines. Several stayed and made their homes there. In this 1936 picture taken in Stotesbury, West Virginia, the men are identified from left to right as follows: (kneeling) Herman Anderson, Joe Tucker, James Tucker, and Jesse Tucker; (standing) Earl Dobson, Sam France, and Jesse Dyson. (Courtesy Bernese Dobson Witherspoon.)

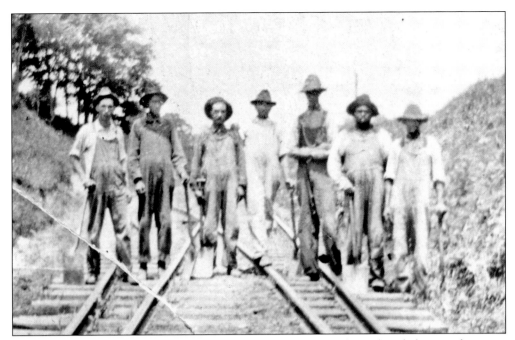

RAILROAD WORKERS. This early 1900s picture was taken on the railroad that ran between Rockford and Winston-Salem. The third man from the left is Wise Dobson, and the sixth man from the left is Joe Dobson. Others are unidentified. They cleaned the tracks and replaced gravel around them. (Courtesy Nora Dobson Penn.)

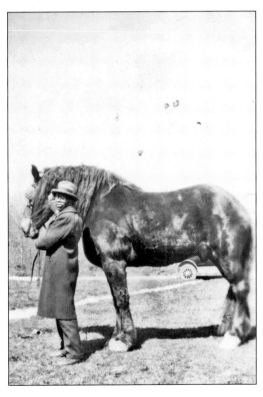

ABRAHAM AND PRINCE. In 1865, "Abe" Taylor was born on the Daniel Taylor Plantation in Big Creek, Stokes County. He married Tempy Ann France and lived on a 150-acre farm in Carroll County, Virginia. In 1919, Prince, the horse, was the most valuable farming helper he had. Farming was unprofitable, so Abraham moved his family to West Virginia to work in the coal mines. (Courtesy Lucy Nora Taylor.)

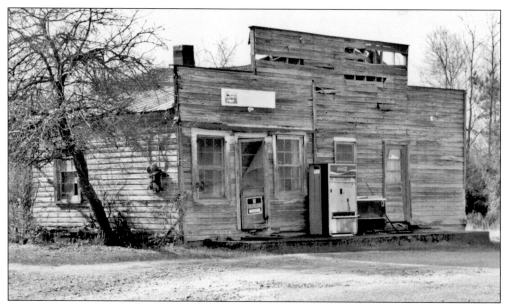

CUNDIFF'S BARBER SHOP. This business was a social spot in the early 1950s. Booneville folk and students could buy 3¢ "pop" (sodas), candy, and cookies. Adults played pool in the front room. Leroy, who had learned to barber in Greensboro and Winston-Salem, cut hair in the rear in the one-chair barbershop to supplement his teaching salary. (Courtesy Steven Greenlee and Ann Radford Phillips.)

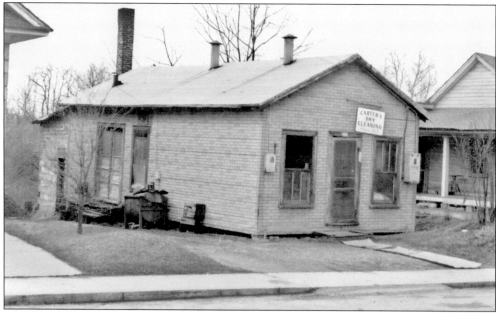

CARTER'S PRESSING CLUB. Richard Carter was a businessman who met a need in the community by providing service and employment during the late 1920s to 1950s. Three of the people he hired were Buster Jones, Mae Bell, and Annie Bell. The dry cleaning business was located on Needmore Street (Virginia Street) in Mount Airy. (Courtesy Elizabeth Conrad Pilson and Buster Jones.)

MILT'S STORE. Milton Warden's general store served the community on Wards Gap Road in the early 1900s. In addition to food staples, candies, and snacks, he sold Gulf gasoline. Milt's store was the city bus and school bus stop. He and American Scales lived in Greentown before moving to a log cabin behind the store. After American's death in 1919, Milton married Jennie Hines, a teacher. (Courtesy Evelyn S. Thompson.)

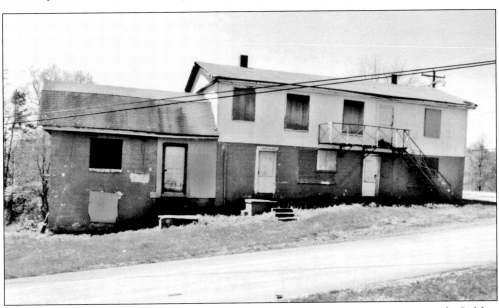

HAYES BUSINESSES. James Hayes worked for the Chatham family, Winston Mutual, Golden State Medical Life Insurance, and Integon Insurance. He acquired real estate holdings with the support of the Chathams. James developed a multifaceted business in the Oak Grove Community in Elkin in the late 1940s. The building pictured here housed a café, a poolroom, a barbershop, a dance floor, and an apartment on the upper level. (Courtesy Jimmy Hayes.)

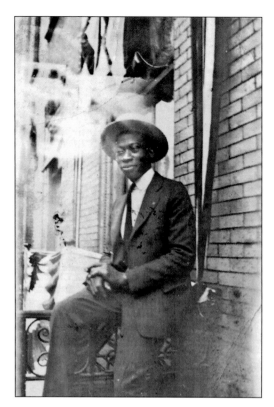

SAM WILLIAMS. This picture of Sam at age 19 was taken in New York, where he attended high school. Sam returned to Mount Airy and opened a shoe repair shop on Needmore Street in 1913; it remained until the 1950s. His slogan was "First Class Work at a Reasonable Price." Sam married Irene Lawrence and had three daughters. He was a violinist and played with the Mallalieu Temple Church choir. (Courtesy Yvonne Williams Lovell.)

WILLIE TUCKER (1901–1965). Willie was an outstanding shoe repairman. It was said that he could make an old pair of shoes look new. He worked in the Skackelford Shoe Shop on Main Street in Mount Airy in the late 1930s or early 1940s. Later, Willie operated his own shoe shop near his parents' home in Pine Ridge, and the shop still stands today. Willie married Viola Cooper. (Courtesy Emma Jean Tucker.)

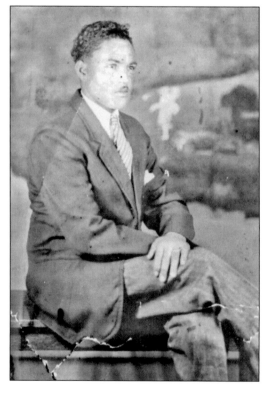

MONROE DODD. This picture of Monroe Dodd was taken in 1942 while he worked at a gas station in Mount Airy. He married Alice Lee Bowman. (Courtesy Emma Lou Bowe.)

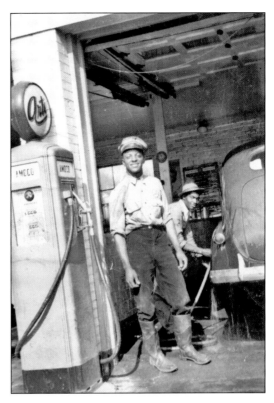

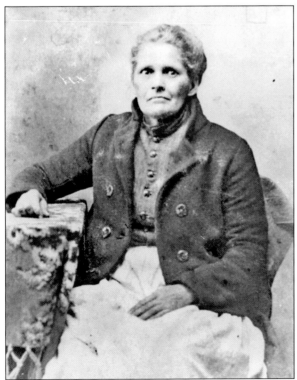

CAROLINE PRINGLE. Caroline was one of several midwives of her time. She delivered babies, sat with the sick, and visited those in need. She often spent nights in the homes of grieving people, comforting and helping them as needed. (Courtesy Ionia H. Smith.)

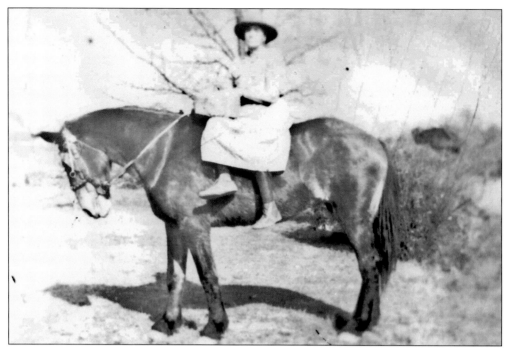

A MIDWIFE. Martha Dobson was one of several midwives in the Surry County area. Her transportation was her pet horse, Nell. Martha rode sidesaddle with her satchel perched in front of her. Both black and white families called on her. She took classes from Dr. R. B. Franklin. Midwives were the only medical care black families received until the late 1940s, and then, they had to wait to be served. (Courtesy Evelyn S. Thompson.)

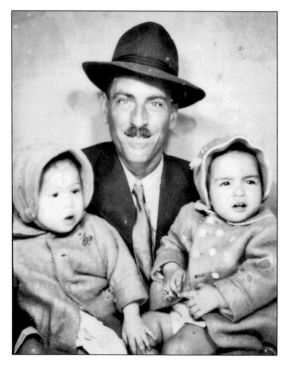

THE BUILDER (1908–1976). George W. Green married Lonnie Sawyers of Patrick County, and they lived in Surry County. George drove a tractor-trailer for Mat Hines. George was a generous building contractor and donated labor to Samuel Grove Church, France Memorial Primitive Baptist Church, and the Claude Smith home at State Line. George's daughter Frances (left) and his cousin Mae Alice Tucker pose with him in the 1942 photograph. (Courtesy Emma J. Tucker.)

ARTHUR JOYCE. An early Surry County successful entrepreneur, Arthur provided a social outlet for people by opening a café in the Ararat community. A tobacco barn was converted into a place of music, laughter, food, and drink. He made moonshine, brandy, and wine, which he served to special customers. He was a Cherokee and married to Zelma Dyson. (Courtesy Brenda Joyce Thompson.)

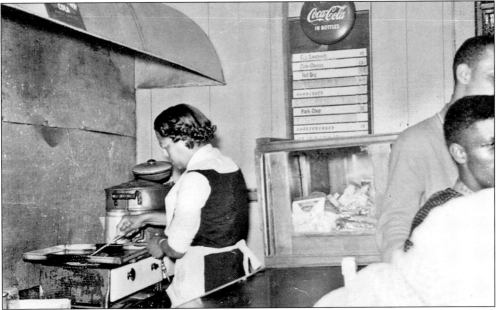

THE BARN. Marie Johnson was a part owner of the Barn café where she cooked and served meals. This 1955 photograph shows Marie preparing one of those meals. She said, "I served as many out of town people as in town. They said the food was real good and they kept coming back." Jukebox music entertained the diners at the café. (Courtesy Marie Johnson.)

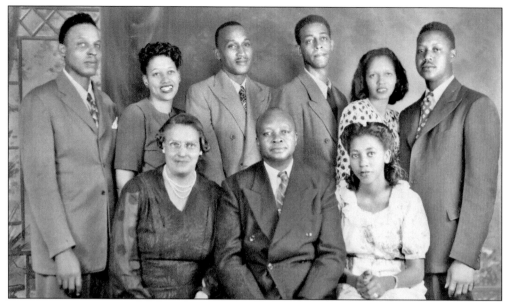

THE LOG CABIN INN. Luther Rawley, son of Dock and Francina Banner Rawley, was born in 1884. Luther was a prominent businessman in the community of Sandy Level, Surry County, and married Willie Simmons in 1905. In the 1930s, they provided a social room called the Log Cabin Inn in their basement. All who came enjoyed home-cooked food, drinks, and music. The Rawleys pose with their children in this 1933 photograph. (Courtesy Josie Rawley Moore.)

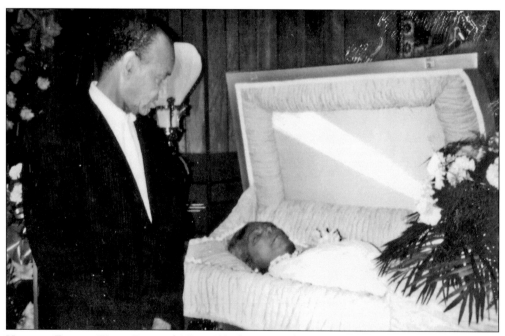

NATIONAL FUNERAL HOME. Bernard "Coot" Tucker owned and operated one of the early funeral parlors, located near his home on Virginia Street. Funeral homes that preceded National Funeral Home were Crawford Funeral Home and Sharp and Smith Funeral Home. In this c. 1955 photograph, Coot examines the quality of his work. (Courtesy Thaxton Tucker.)

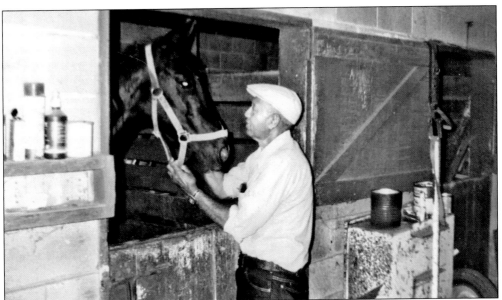

MALACHI "BUSTER" JONES. Taught horse training by his father, Buster attends one of the horses under his care in this photograph. He was hired by whites to train their horses. Throughout his life in Mount Airy, Buster worked for the North Carolina Granite Corporation, the Hadleys, the Carter's Pressing Club, and the Holcombs. Buster and his late wife, Myrtle, enjoyed a long and pleasurable relationship with the Holcomb family. (Courtesy Malachi "Buster" Jones.)

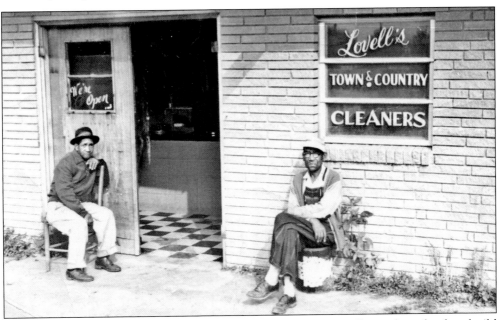

LOVELL'S CLEANERS. About 1955, J. T. Harris helped Baxter Lovell purchase land to build this dry cleaning business in Pilot Mountain. It operated until the early 1960s. Seated in front of the building is Graham Staples on the left and Jimmy Joyce on the right. (Courtesy Lydia Lovell.)

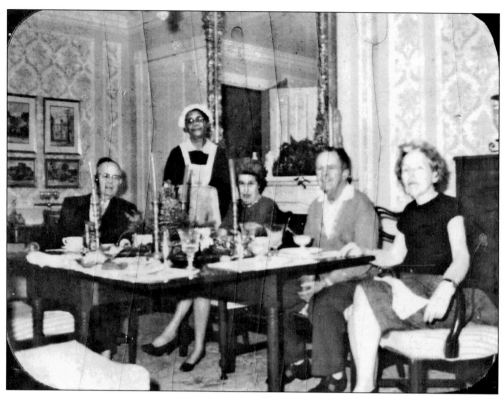

THE HOUSEKEEPER. Myrtle Johnson Rogers is pictured in this *c.* 1954 picture serving the Smith family at their home on Main Street in Mount Airy. From left to right are Dr. ? Smith, Myrtle Rogers, Isabel Smith, "Buck" Smith, and Gertrude Smith. Myrtle worked for the family for 33 years. The house is now a historical site where Myrtle's room and uniform are on display. (Courtesy Marie Johnson.)

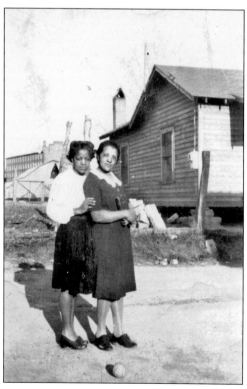

NORA'S CAFÉ. Nora Ousley (1909–1990) operated a café on Needmore Street (Virginia Street) in Mount Airy. In the mid-1940s, $1.25 bought a meal consisting of meat, two vegetables, dessert, bread, and a drink. Nora cooked for First Presbyterian Church functions, Reeves Community Center, Doe Run Lodge, and Mary Bennett. Nora was first married to Powell Ousley and then James Glover. Her daughter Eula poses with her in Kapps Alley. (Courtesy Emma Jean Tucker.)

THE PHOTOGRAPHER. Allen John Roberts (1908–1962) was employed for many years by Dr. Roy C. Mitchell, a medical doctor, of Mount Airy. Allen enjoyed photography and was responsible for most of the pictures taken during the 1920s and 1930s in the Surry County community of State Line, where he lived with his parents. This *c.* 1938 photograph shows him in his darkroom developing pictures. Allen was also an excellent cook, and he cooked for his parents and employers. (Courtesy Emma J. Tucker.)

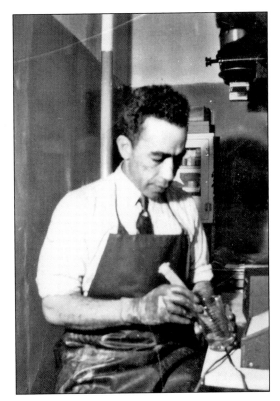

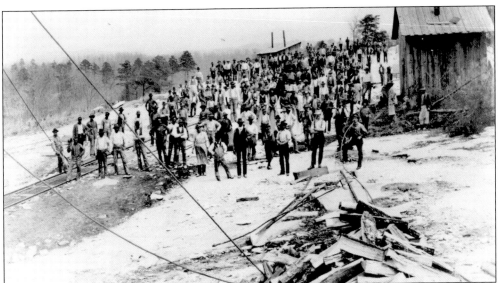

THE "ROCK." The Mount Airy granite quarry is the largest open-face granite quarry in the world. Eli Fraiser, an ex-slave, acquired 40 acres of the "Rock." He sold it for a rooster and a shotgun. In 1888, the potential for the granite was realized. With the advancement of the railroad and the transportation of granite, many black men found work at the quarry as stone cutters. Over the years, they attained other types of jobs. (Courtesy Surry County Historical Society, Nathaniel McArthur.)

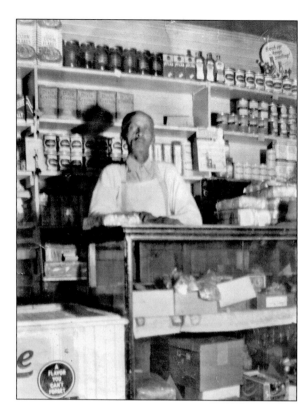

BOWMAN GROCERY STORE. Willie Bowman, standing behind the counter in this 1939 photograph, built this store in 1920 in the Ararat community. It was one of two stores in that community. (Courtesy Margaret Bowman Haliburton.)

AARON'S PLACE. After Willie Bowman retired, his son Aaron operated a place in the Ararat community where young people could hang out. It was open on Saturdays until midnight and on Sundays until 11 p.m. On school nights, it was off-limits. The strongest drink was "Double Cola," and no foul language was accepted. When Aaron spoke, the young people listened. The business remained in the family until 1953. Other entrepreneurs later operated businesses from the building. (Courtesy Margaret Haliburton.)

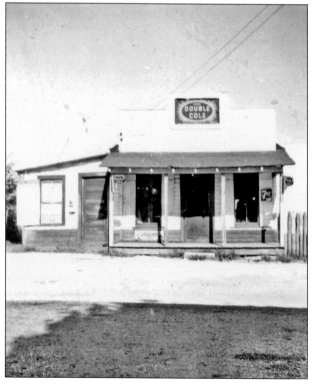

Six

LEISURE
A Time for Reflection

The grace with which we embrace life, in spite of the pain, the sorrow,
is always a measure of what has gone before.
—*Alice Walker, 1970*

Plantation life limited leisure among the slaves. Social activities were closely tied to work. Working groups of slaves or individuals could be heard moaning or singing songs. They beat makeshift drums, tapping to the rhythm of songs.

After the Emancipation Proclamation, ex-slaves were busy building homes and neighborhoods, so time was limited for entertainment. As before, people mixed socializing with work, singing, sharing ideas, and telling stories. Neighbors gathered at corn shuckings, hog killings, and barn raisings, and women prepared large dinners for the occasions. Quilting parties were held to make warm bed coverings. The fiddle, banjo, guitar, and harmonica were favorite instruments among musical groups, which sprang up and took entertainment to another level. They entertained at backyard celebrations and church meetings. Church associations drew people from a distance to the church grounds. These types of activities developed a unified and cohesive community.

As leisure time grew, so did social and entertainment activity. Neighborhood baseball teams challenged each other. Sunday afternoon visitation among families was a favorite pastime. Most parents had large families, so children visited with each other. As transportation improved, families visited neighborhoods at a greater distance and went to the theater. Schools became the central arena for family entertainment. Children competed in sports, participated in theater, sang in chorus, and participated in Scouting. Families of all the neighborhoods attended and supported the school activities.

—*Eunice C. Jessup*

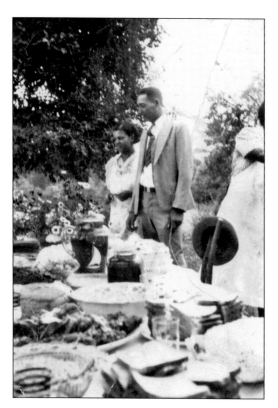

BACKYARD CELEBRATION. This 1932 picture shows a typical summertime celebration. This party was held in the backyard of Ernest and Viola Dobson's home in the State Line community. People gathered outside, enjoying home-cooked food. (Courtesy Maggie S. Rosser; photo by Allen Roberts.)

A LEISURELY SUNDAY AFTERNOON. In 1942, Sunday afternoons in the Wards Gap community were spent visiting neighbors. The teens gathered at the Scales family home in Surry County are, from left to right, Odessa Penn, Lummie Scales (seated), Dora Taylor, Angel Taylor, and Catherine Penn. (Courtesy Maggie Rosser.)

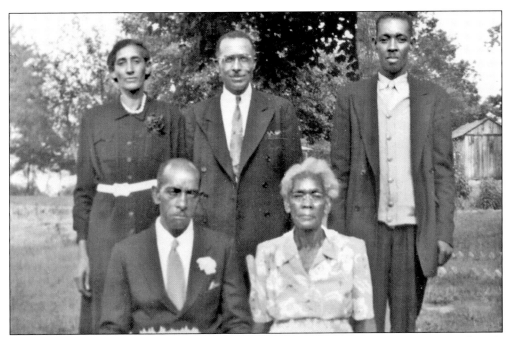

A Celebration. On the second Sunday in May 1936, at the Stewart home, family and friends celebrated a surprise birthday party for Edgar and Sarah. In those days, much of the activity was held on the porch and yard. In the picture, from left to right, are (seated) Edgar Stewart and Sarah Graham; (standing) Lettie Stewart (Sarah's daughter); Elder Joseph Scales (pastor); and Henry Graham (Sarah's son). (Courtesy Doris Stewart.)

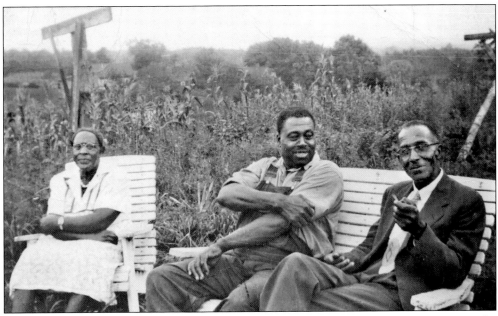

Visiting Pastor. Families of the State Line Primitive Baptist Church could expect visits by the pastor. In 1952, Elder Joseph Scales (right) chats with Alice Taylor and Robert Moore at Moore's home in the Ararat community. (Courtesy Maggie S. Rosser.)

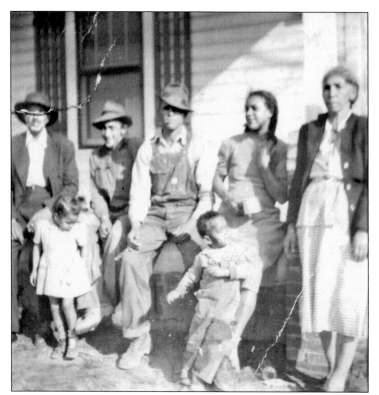

THE PILOT MOUNTAIN GANG. In this *c.* 1939 photograph, children enjoyed playing "cowboys and Indians." From left to right are Cecil Thompson, Eugene Cox, Charles Thompson, Oscar Lee Cox, Alphonso Tillman, and John (T. K.) Thompson. (Courtesy Alphonso and Prelette Tillman.)

JAMES BOWMAN (1910–?). James was the only child of Mary Bowman, who died in childbirth. Pauline Greenwood, James's grandmother, raised him. James was a body builder and boxer. His grandmother did not live to see his nine children. (Courtesy Roy Bowman.)

BLACK SOX TEAM. The team poses at the ballpark behind the white high school, where home games were played. Team members in 1945, from left to right, are as follows: (first row) Jarvis Forrest, seated; (second row) Wallace East, Fred Lovell, John Smith, Joe Forrest, Jesse Moore, and Eddie "Sonny Buck" Cobb; (third row) Walter Archie, Hessekiah Hughes, Edison East, Oscar Lee Cox, Cecil Thompson, and John Reynolds. (Courtesy Alphonso and Prelette Tillman.)

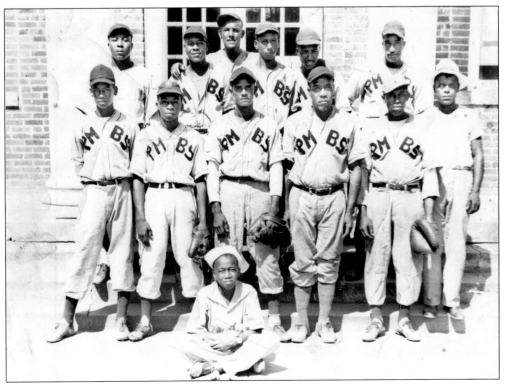

OSCAR DOBSON. Oscar was a professional ventriloquist and magician. Black and white audiences attended his performances in Mount Airy. Friends gathered at his parents' home to watch his homemade dolls, Sambo and Dinah, appear to come alive. He married Pauline Dooley of Salem, Virginia; they had five sons. In the early 1930s, Oscar abandoned his family for a life on the other side of the color line. (Courtesy Evelyn S. Thompson.)

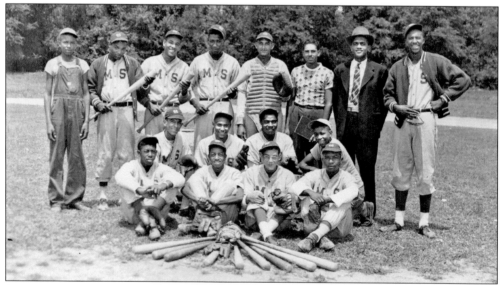

SENATORS BASEBALL TEAM. From the late 1930s to the 1950s, the Senators played baseball games on the fairground behind Mount Airy High School. Competitive teams came from nearby such towns as Pilot Mountain, Tobaccoville, Boonville, and Elkin, North Carolina; Bluefield, West Virginia; and Pulaski, Virginia. When this 1947 photograph was taken, Howard Cox was manager. Other managers were George Moore and Joe Beck Moore Jr. (Courtesy Carlen Gray Scales.)

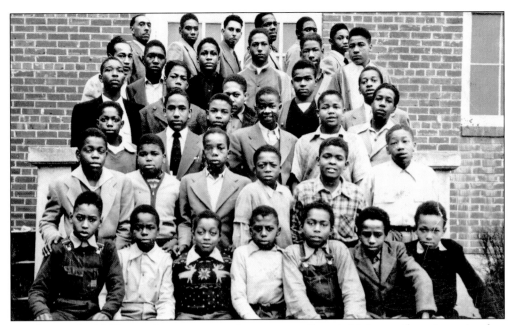

Boy Scouts. In 1945, scouting was a popular program. Francis M. Jones, the science teacher at the high school, was the Scoutmaster. (Courtesy Carlen Gray Scales.)

The Grand Theater. Movies were available to those who could travel downtown and who had money for a ticket. The Jim Crow laws dictated that people of color go to the back entrance of the movie theater. However, the balcony offered a clear view of the screen. (Courtesy Evelyn S. Thompson.)

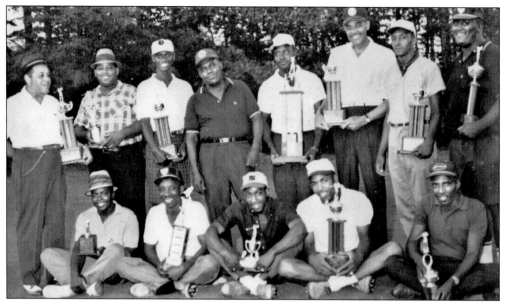

GOLFING WITH A HANDICAP. Paul Reynolds represents the many young males who caddied at the "white only" Mount Airy Country Club. He learned the game of golf well and continued to develop his skills while working in Westmoreland Coal Mines in West Virginia. This *c.* 1955 picture shows Paul (first row, second from left) with other winners. He won first runner-up in the Winston-Salem Lake Championship Golf Tournament in Winston-Salem. (Courtesy Ernestine Reynolds.)

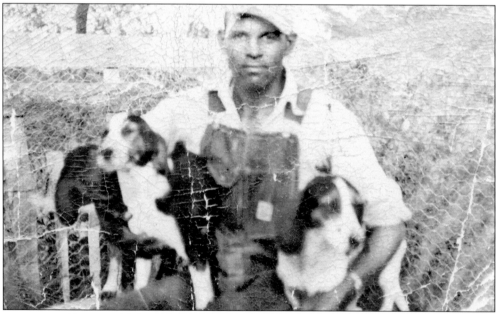

JOHN HENRY TRAVIS. John loved his hunting partners. In 1939, he was a master at hunting. He brought fresh wild game to his family and often had enough to share with those not as skillful. He shared rabbits, opossums, coons, and foxes when the catch was good. (Courtesy Shirley Bowens, photograph by Allen Roberts.)

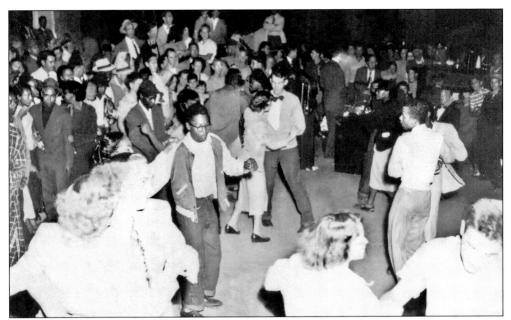

FARMERS' DAY CELEBRATION. This farmers' day celebration was sponsored by a civic organization for everyone. Blacks and whites danced together on Main Street in Mount Airy in the 1950s. The photograph was taken in front of Boyles Shoe Store. Some attendees were Aaron Sawyers, Earl Warden, Mae Bell, Minnie Cockerham, Bobby Stewart, Elizabeth Valentine, Martha A. Strickland, Jessie Crawford, Elizabeth Conrad (center), Charles Carter of Paynetown, and Arthur Bell. (Courtesy Elizabeth Pilson.)

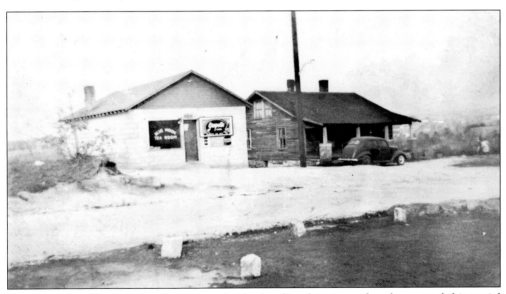

BLUE MOON TEA ROOM. Josie Massey, a retired schoolteacher, owned and operated this social center in Sandy Level, now West Virginia Street, in Surry County. In the early 1940s, it was a popular weekend social center offering sandwiches and drinks. The jukebox supplied the dance music. People of mixed ages enjoyed the weekend, and it was known to be a safe place for teens. (Courtesy Sonya Dodd.)

MADOC RECREATION CENTER. In the late 1950s, a group planned the Madoc Center on Virginia Street, the first recreation facility for people of color. They were Bernard Tucker, Cornell Rawley, Malachi "Buster" Jones, Charlie Bowman, Sollie Gilbert, Rev. J. T. DeLoache, Leonidas Jones, Clint H. Carter, John Sawyers, Ed Davis, and Rev. James Strickland. Students from Levi Gee's classes at J. J. Jones High School provided labor. (Courtesy Malachi "Buster" Jones.)

CIVIC ORGANIZATIONS. A Masonic fraternity was in Mount Airy as early as 1905. The Odd Fellows met on Needmore Street in the early to mid-1900s. Around 1940, the Scottish Rite Free and Accepted Masons came to Mount Airy. These organizations paved the way for a Masonic Lodge and two Orders of Eastern Star. The Star of Hope Order of Eastern Star (OES) chapter was organized in 1950 in Mount Airy. (Courtesy Perry March.)

118

CHALLENGER. In 1947, Charles B. Hauser, a native of Yadkin County, was residing in Winston-Salem when he was arrested in Mount Airy for refusing to move to the back of the bus. He was traveling to West Virginia State College, where he was a professor. The Atlantic Greyhound Corporation settled the false arrest case by paying Charles $2,000. Interstate transportation was desegregated in 1943. (Courtesy Dr. Charles Hauser.)

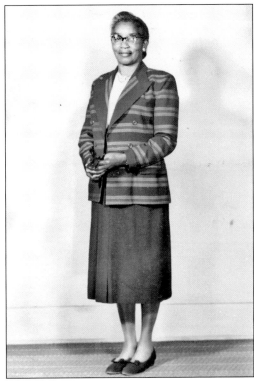

SMITHIE FRANCE REYNOLDS. Smithie (1892–1981) was employed as a domestic for Fred Jarrell in Mount Airy. In 1949, at age 57, she challenged the Jim Crow bus law by sitting in the front of the bus traveling between North Carolina and Tennessee. Smithie remained in her seat until arrested. Fred Jarrell paid her bail of $100. Smithie went to court, was found guilty, and was fined $25 and $300 for court costs. (Courtesy Sonya Dodd.)

NAACP. Louise Conrad Waddall (above, left), Mary Conrad Strickland (above, right), and Iona Stewart (left) initiated the first meetings that led to organization of the first Surry County chapter of the National Association of the Advancement of Colored People. The national organization had begun some 50 years earlier. They wanted better jobs, working conditions, pay, and opportunity for all. The first president was John Lovell of Pilot Mountain. Meetings were held in Zion Baptist Church on Virginia Street. (Courtesy Elizabeth Conrad Pilson and Yvonne Lovell.)

Seven

MILITARY
A Soldier's Story

Freedom is not free.
—*Martin Luther King Jr., 1959*

In 1942, at the age of eighteen, I, Thomas Hatcher, enlisted in the Army Air Force. The next twenty-six years shaped my life. My pay was fourteen or fifteen dollars a month; others received one dollar a day. After pulling "scrub duty" for hiding food to clean my plate, I learned to match the food with my appetite. Until 1948, black soldiers served under all white officers.

Race relations mirrored that of the larger society. Acts of racial hatred were perpetrated against black soldiers. Buses, transporting soldiers from Camp Stewart Georgia to Savannah, were showered with rocks. Soldiers were attacked; I know of one that was killed. Soldiers rebelled. Black soldiers could be court-martialed if found traveling without a pass.

As a guard of prisoners, I was court-martialed for shooting a prisoner in the leg to stop his escape. I would have had to take his place had he succeeded. While working in the grain fields of Nebraska, eight hundred black soldiers were court-martialed for burning a stadium stand in order to get warm.

Racial insults followed me to Okinawa in 1961. The commanding officer demanded that I, as Sergeant, not allow the men to rest while clearing boulders. I allowed rest. The officer said, "If I had you back in Georgia, you'd lose your life."

Experiences took me to several states and nineteen countries. One of my most memorable experiences was contact with Chappie James, the first black General, when I serviced his air craft four times. At one time, Lieutenant Jackie Robinson was my commanding officer.
—Thomas Hatcher, as interviewed by Evelyn Scales Thompson, Ph.D.

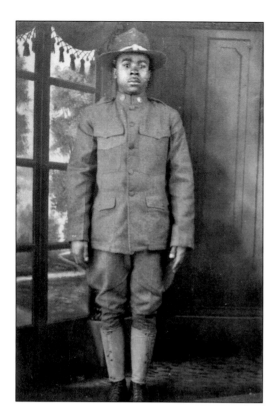

JAMES HENRY TAYLOR. James was inducted in the army in August 1918 and served in World War I until July 1919. He received medals of decoration and a Victory Medal. His bonus pay was $101.35. (Courtesy Lucy Nora Taylor.)

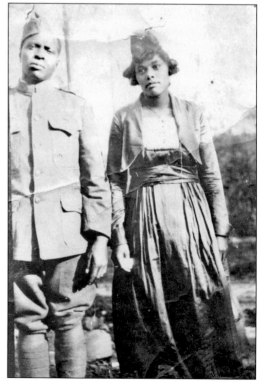

ROBERT HUGHES SR. "Bob" (1890–1956) served one year, from 1917 to 1918, as a Buffalo Soldier in World War I in France. Sudie Irene Arnold (1897–1987), his future wife shown in this picture, was a graduate of Slater Normal School (Winston-Salem State University). She taught school in Stokes County before marrying Bob. (Courtesy Opal Hughes.)

BUFFALO SOLDIERS. Walter Hughes, like his father, Robert, of Surry County, served in the all-black 365th Buffalo Infantry Division. He was stationed in Italy and served from 1942 to 1947. He was one of three sons to serve in World War II. (Courtesy Opal Hughes.)

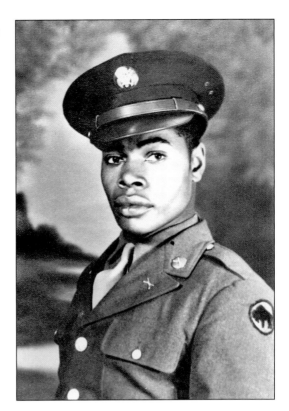

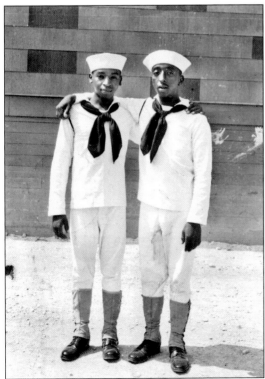

U.S. NAVY MEN. Brothers John and Fred Lovell from Surry County represent the men who served in defense of their country aboard ships during World War II. Several families had more than one male serve in the war. (Courtesy Josie Ann Moore.)

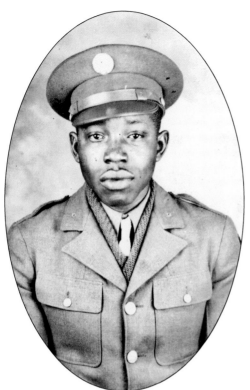

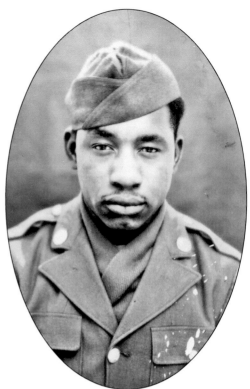

(Above, Left) **PAUL REYNOLDS.** The son of James and Smithie Reynolds, Paul was born in Stokes County. Smithie was a widow when five of her six sons served simultaneously in World War II. Jack was the son who did not serve in the military. (Courtesy Ernestine Herring Reynolds.)

(Above, Right) **HARRISON REYNOLDS.** "Harry" (1925–1998) was born in Stokes County to James and Smithie Reynolds. He was a career soldier with the U.S. Army. (Courtesy Cheryl Reynolds-Small.)

LOUIS REYNOLDS. This is one of the five sons of James and Smithie Reynolds to serve in World War II. (Courtesy Cheryl Reynolds-Small.)

EDWARD REYNOLDS. "Ed" is another of the five sons of James and Smithie Reynolds to serve in World War II. (Courtesy Cheryl Reynolds-Small.)

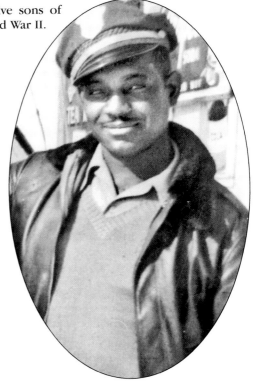

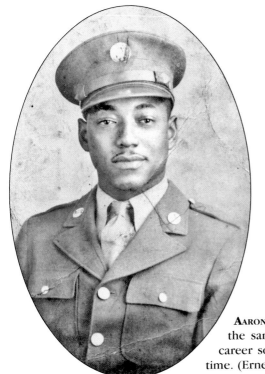

AARON REYNOLDS. Aaron served in World War II at the same time as four of his brothers. He was a career soldier and is the only brother living at this time. (Ernestine Herring Reynolds.)

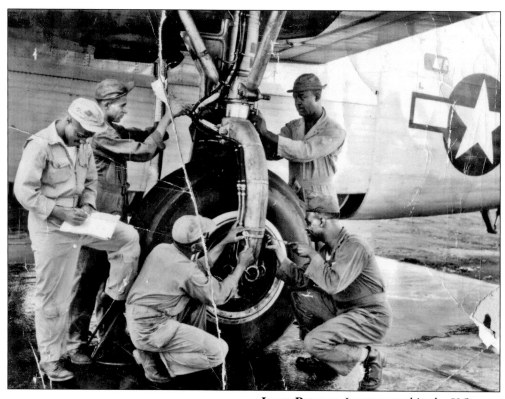

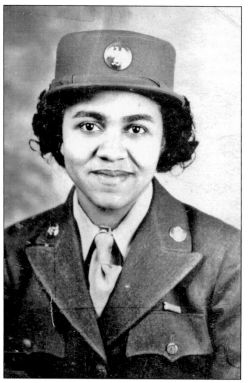

LEROY BOWMAN. Leroy served in the U.S. Army Air Force from 1943 to 1946. An airplane engine mechanic, he received the American Service Medal and an honorable discharge. Leroy is identified in this picture as the first person moving counter-clockwise. (Courtesy Roy Bowman.)

FIRST SURRY COUNTY WAC. Helen Ceasar served in the U.S. Army WAC between 1942 and 1946. She is the daughter of Dillard and Lucy Ceaser of Surry County. (Courtesy Calvin Ziglar.)

LETTER FROM A SOLDIER. Frances Brim of Surry County received this letter from her husband, Brady, while he served in World War II. (Courtesy Frances R. Brim.)

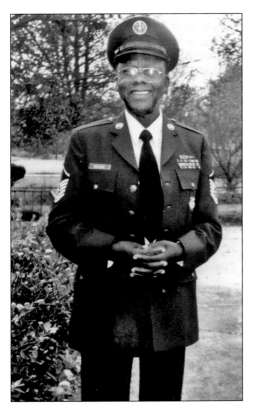

MILITARY CAREER. Thomas Hatcher represents those enlisted soldiers who volunteered to serve in the military during World War II. He joined the U.S. Army Air Force because his brother had been drafted and switched to the U.S. Air Force after it was formed in 1947. He retired in 1965. (Courtesy Thomas Hatcher.)

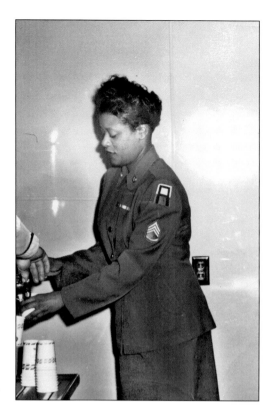

A Second WAC Serves. Audrey Jacqueline Waugh was the second African American woman of Surry County to serve as a WAC. She enlisted in 1950 and retired in 1970. "Jackie" is the daughter of Leone Rawley Cannon. (Courtesy Audrey Waugh Brown.)

Levi Lincoln Sawyers. Lincoln served in the Korean War and represents the men who gave their lives for democracy. Drafted at the age of 22, he was the son of Neal and Cora Sawyers of Surry County. (Courtesy Adron Sawyers Martin.)